IMAGES
of America

AROUND
WESTHAMPTON

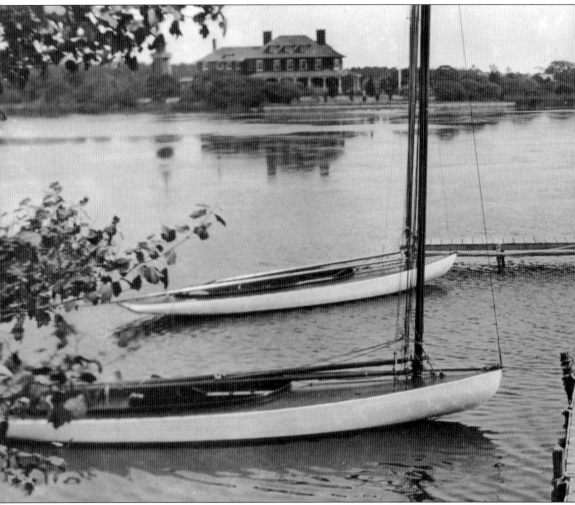

MEADOWCROFT DOCK, C. 1907. Theodore E. Conklin's 100-acre Quiogue farm Meadowcroft was one of the first of many handsome estates to be constructed along Westhampton's waterfront. Conklin's two BB Class sailboats *Adelaide I* and *Adelaide II*—25-foot-long gaff-rigged sloops with a revolutionary Herreshoff bow that were built by famed boat smith Gilbert Smith—are moored to the Meadowcroft dock, with a Quiogue estate visible in the background across Quantuck Creek. (Courtesy Theodore B. Conklin Jr.)

ON THE COVER: SAILING ON MORICHES BAY, 1930. On summer weekends, the bays around Westhampton are often dotted with sailboats. Under sail in this 1930 photograph are SS wooden one-design sailboats that were designed in 1908 by Benjamin Hallock specifically for the shallow bays in the Westhampton vicinity. The 16.5-foot-long gaff-rigged SSs are one of the country's oldest one-design boats still being raced today. (Courtesy Ethel Hillyer Medina.)

IMAGES
of America

AROUND
WESTHAMPTON

Meredith Murray

ARCADIA
PUBLISHING

Published by Arcadia Publishing
Charleston SC, Chicago IL, Portsmouth NH, San Francisco CA

Printed in the United States of America

Library of Congress Control Number: 2009936026

For all general information contact Arcadia Publishing at:
Telephone 843-853-2070
Fax 843-853-0044
E-mail sales@arcadiapublishing.com
For customer service and orders:
Toll-Free 1-888-313-2665

Visit us on the Internet at www.arcadiapublishing.com

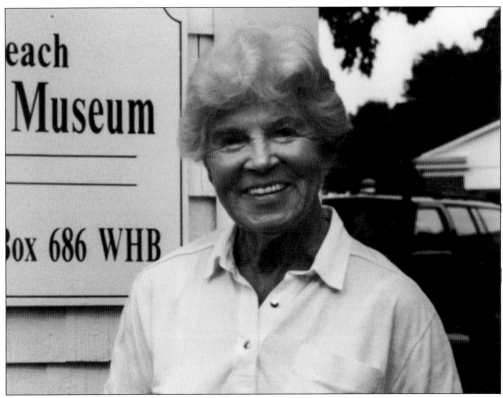

MARION RAYNOR VAN TASSEL, 1921–2009. A driving force behind the formation of the Westhampton Beach Historical Society, Marion was its most enthusiastic and knowledgeable supporter. All royalties from the sale of this book will be donated in her name to the historical society for the restoration of the Foster-Meeker House. (Courtesy Meredith Murray.)

CONTENTS

ACKNOWLEDGMENTS

Special thanks go to those members of the community who have donated their photographs and family histories to the Westhampton Beach Historical Society, and to the volunteers who have tirelessly and lovingly archived into the society's collection the history of the villages and hamlets that make up Westhampton. This collection of historic photographs could not have been put together without the help of the many families who have graciously shared their family memorabilia—Raynors, Culvers, Halseys, Rogers, Kiddes, Havens, Howells, Jaggers, and so many more. Thanks, too, to the many people who provided photographs and information to update this story to the present time and to the local residents who served as fact-checkers: Wesley Culver Winters, Jackie Parlato Bennett, Charles Marvin Raynor, Dean Speir, and Ron Michne Jr. Because this publication required the use of only high-resolution, archival photographs and because the selection of available pictures was limited, many individuals and organizations worthy of inclusion in a history of Westhampton will not be found in these pages. Photographs from private collections are credited as such; all other images are from the collection of the Westhampton Beach Historical Society.

INTRODUCTION

Westhampton is a 15-square-mile area of the south shore of eastern Long Island in the state of New York, with a year-round population of 7,000 or so and a flourishing summer resort head count of more than 30,000. The area referred to in this account as "Westhampton" includes the hamlets of Westhampton and Quiogue, as well as the incorporated villages of Westhampton Beach and West Hampton Dunes.

Only 75 miles east of Manhattan, it is the first of the Hamptons on the Long Island Railroad's eastward track and also the first community on the East End with easy access to both the Atlantic Ocean and to the bays of Long Island's South Shore. Blessed with moderate temperatures; wide, white-sand beaches; and the natural beauty of sand dunes, waterways, and salt spray roses, with efficient transportation to New York City, New England, and beyond, it is a resort area of international repute.

Hundreds of years before this pastoral waterfront became known as Westhampton, long before it was labeled one of the famous "Hamptons" by tourist guides, it was the land of the Catchaponacks (a family of the Shinnecocks). A proud Native American tribe who lived off the plentiful riches of the area, they gathered nuts in the forest, hunted deer and muskrats on land, speared whales in the ocean, and caught fish and eels in the bays.

The Catchaponacks (sometimes Ketchabonecks or Ketchaponacks), one of many tribes and families that made up the Algonquin Nation, settled along the waterfront on either side of Apaucuck Creek (Beaver Dam Creek today). They made their wigwams out of the cattail flags that grew along the marshes, hunted whales by driving them through narrow inlets and trapping them in shallow water, and grew 20 varieties of corn that they fertilized with the small bait fish called menhadan.

In 1660, the English acquired land west of the Shinnecock Canal from the Montauks' Chief Wyandanch for 70 pounds sterling, a few bushels of corn, and a bag of coats and trinkets. Shortly thereafter, the first white men arrived on the banks of Quantuck and Moriches Bays. They were sheepherders and cattlemen, who drove their flocks from the English settlement in Southampton to the grazing lands and salt hay meadows of Catchaponack, Potunk, and Oneck—the area that is today Westhampton and Westhampton Beach. The herdsmen built small sheds in which to live, and by the early 1700s a village had grown up at the head of Beaver Dam Creek, just east of the large pond known now as Beaver Dam Pond. With the establishment of a mission house for worship and schooling, a mill to grind the farmers' grains, a dry goods store, an icehouse on the pond, and, in 1765, a post rider who dropped the mail in the hollow of a tree not far from the pond, the community of Catchaponack was born.

The village grew, stretching down Mill Road to Main Street (which became the commercial center), with fishing, farming, and lumbering being the primary income-producing occupations. Jonathan Raynor and Hezekiah Howell were the first to buy acreage in Catchaponack, the Native American name for "a place where large roots grow." Then John Jessup and Thomas Stevens

bought lands in adjacent Potunk, "where the foot sinks into the mud," and Thomas and Isaac Halsey took over Oneck, "the bend in the shoreline."

The families of the original settlers multiplied—Halseys, Raynors, Jessups, Rogers, Howells, Stevens, Fosters, and others—and came to be thought of as the foundation blocks of eastern Long Island's population. The village was named and renamed—Catchaponack became Westhampton, then Westhampton Center in 1880, and in 1890 Westhampton Beach. Catchaponack's lines were officially redrawn in 1928 when the village of Westhampton Beach was incorporated, leaving the hamlet of Westhampton on its western flank and the hamlet of Quiogue on its eastern flank. (West Hampton Dunes came into being in 1993, when the western end of Dune Road was incorporated into a village following the disastrous erosion of the barrier dunes, which were subsequently rebuilt.)

Over the centuries, near-catastrophes have threatened the area in the form of hurricanes, foreign wars, the Civil War, and even climate abnormalities. According to Native American lore, the people of Catchaponack survived an August 1635 hurricane by climbing high into the treetops. The British housed soldiers in three Westhampton homes during the Revolution to keep a watchful eye on the resentful patriots, and 10 Westhampton men, with old Long Island names like Tuthill, Griffing, Havens, Wines, and Raynor, died in what an 1865 commemorative monument refers to as "the war for the preservation of the Union." Climate disasters occurred periodically, ruining the crops and alarming the townspeople. In 1762, no rain fell from May to November. In 1816, the year without a summer, there was frost in every month, with snow in June, and in 1885 and 1918, the winters were so bitterly cold that the ocean froze along the shoreline.

But Westhampton has also had to survive the challenges that come from popularity and population growth. As early as the 1840s, urban dwellers seeking relief from steamy, hot cities discovered eastern Long Island as a vacation paradise. First the urban visitors rented rooms in farmhouses for a week or two in July or August, and then summer vacationers took seasonal space in boardinghouses. When the extension of the Long Island Railroad made traveling comparatively easy, many of those who had previously rented rooms built their own houses on the East End, and the resort area known as "the Hamptons" was born.

In time, Westhampton's expanding summer population included not only families from New York City and New Jersey, but in the late 1800s celebrities such as John Barrymore, Thomas Edison, and P. T. Barnum, and, 100 years later, Cary Grant, Joan Crawford, and Howard Cosell. But Westhampton is not and never was a center for glitz and glamour. It is a place people come to for peace and for the quiet enjoyment of a beautiful scene.

The village of Westhampton Beach and its surrounding hamlets have not changed all that much in the last century, except for the addition of a new modern library and a few more community activities, such as the Concerts on the Green, the end-of-summer Lobster Bash on the biggest of the public beaches, and the historical society's potluck-supper Memory Nights. The Native Americans, whales, and cranberry bogs are largely just a memory, but the creeks, bays, ocean, and miles of beaches still make Westhampton a place of wonder.

Around Westhampton is the story of how Westhampton managed to retain its original character as the community evolved from a simple farming village into a so-called "summer playground." In Westhampton, corporate executives and Hollywood celebrities blend discreetly with clammers, farmers, and local families into a fabric that still retains the character of the Catchaponacks' homeland.

One

CATCHAPONACK
1650–1850

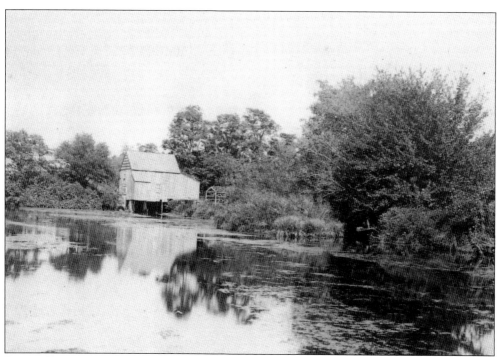

BEAVER DAM CREEK. Westhampton began here, at the head of the creek, alongside a freshwater pond. The Catchaponacks and the Apococks, family groupings of the Shinnecock Nation, greeted the white men peacefully when they arrived around 1650, driving herds of sheep and cattle west from Southampton.

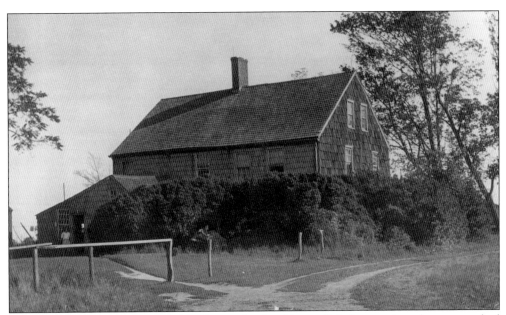

CATCHAPONACK'S FIRST HOUSES. The first settlers lived in small shelters, such as the one attached to the Raynor farmhouse. Thurston Raynor (1874–1961) was the last of five generations to have lived on this homestead, built in the mid-1700s by Jonathan Raynor's son Nathan. In 2005, it was torn down to make way for new construction, but the milk house was saved and is now part of Westhampton's Historical Museum.

LOP TREES. Early farmers often planted lop trees (a type of oak), with trunks conjoined and branches sweeping low, to define their property borders. In 1952, there were many lop trees still alive for Susan and Peter Rogers, the children of Blair and Edward H. Rogers Jr., to climb. Because the intertwined trunks of the trees on Oneck Lane also provided cozy seating, the road became known as "Lovers' Lane."

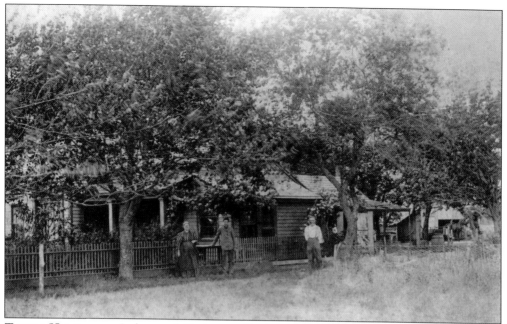

TUTTLE HOMESTEAD. Joshua and Christiana Tuttle stand with their son Jesse in front of their homestead in the 1870s. Property generally passed to the eldest son. The Tuttle's neighbor, Isaac Halsey, left his Oneck Lane land, dwelling, and two slaves to his son in 1740. To his wife, Isaac generously bequeathed the use of the southwest bedroom for six months and all the butter and cheese of her own making.

COOK'S MILL. John Cook, pictured with Irving Downs and Downs's spaniel, Snaps, owned the mill at Beaver Dam in the early 1900s, when a trip to the mill to grind corn was still considered a great social occasion. Cook's Pond is on the right, and Beaver Dam Creek, with the mill wheel, is to the left. The mill was taken down in 1933 to make way for Montauk Highway.

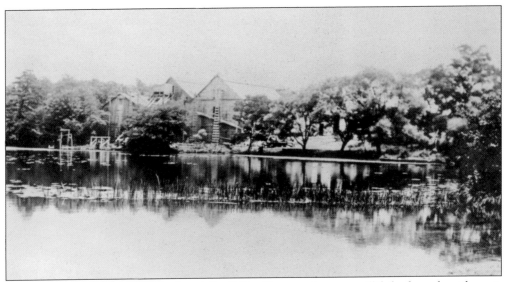

THE ICE FACTORY. Beaver Dam Creek and Cook's Pond became the center of life for the early settlement. Farmhouses were built along the grazing grounds of what is now South Road, fish houses filled with nets and fishing equipment lined the creek banks, and an ice factory (shown here as it looked in 1900) was built on the east side of the pond, where Beaver Dam Condominiums are today.

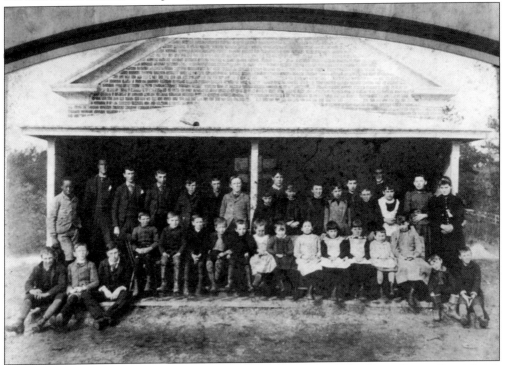

THE OLD BRICK SCHOOL. Built in 1856 to replace a wooden 1815 building, Beaver Dam's brick schoolhouse was situated east of Cook's Pond and just west of the cemetery and the (1742) Beaver Dam Presbyterian Church. The church, which evolved from the mission house, was probably the area's first school, and it was for boys only. By 1872, the brick schoolhouse had an enrollment of 47 students, including girls.

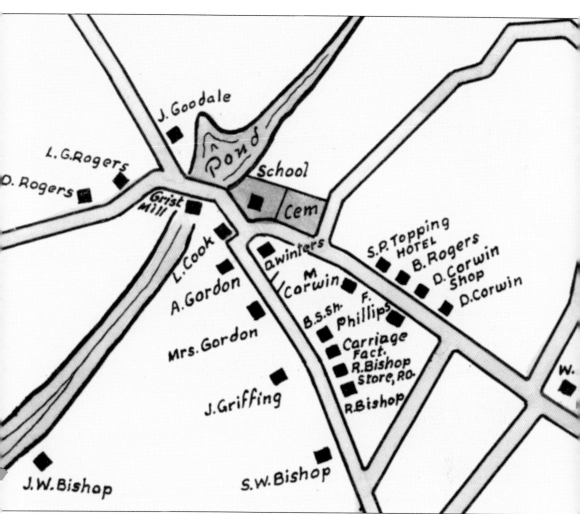

THE BEAVER DAM COMMUNITY, 1870. By 1870, Beaver Dam had a school, cemetery, Presbyterian church, mill, boatbuilder, carriage factory, dry goods store, and even a hotel. But a mile southeast in Catchaponack, a commercial Main Street was beginning to grow that would very shortly become the center of the settlement. In 1880, Catchaponack renamed itself Westhampton Center, then, in 1890, Westhampton Beach. Beaver Dam became the hamlet of Westhampton.

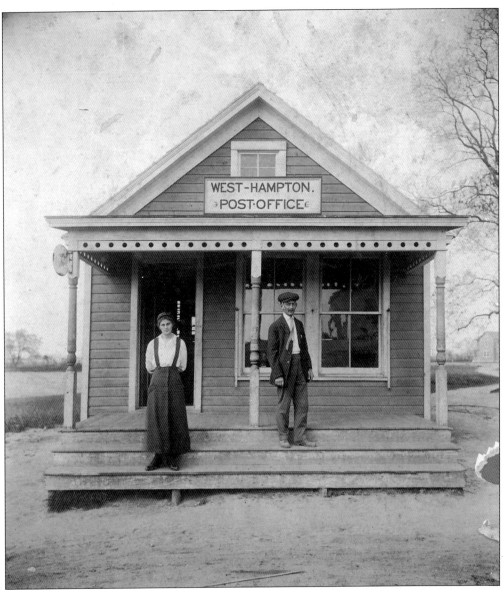

WESTHAMPTON POST OFFICE. Beginning in 1765, a post rider traveled on horseback from New York City east to Southold, pausing at Beaver Dam to leave mail in the hollow of a tree. In 1861, Beaver Dam opened a real post office on Mill Road under the name West-Hampton, with William C. Raynor as postmaster. He is shown here with a Mrs. Kelling.

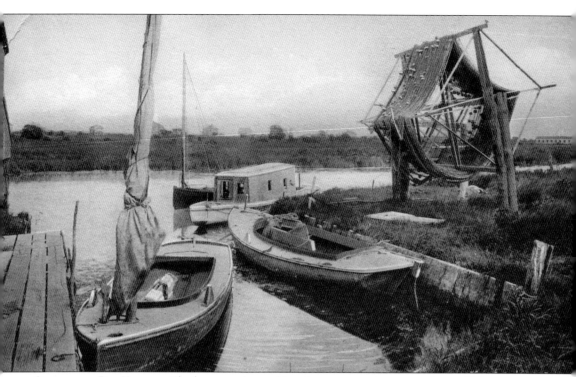

OCEAN AND BAY FISHING. The bays, creeks, and beaches supported great numbers of fishermen, and whales were commonly spotted offshore until the mid-1800s. Inland waterways consisted of brackish freshwater before permanent ocean inlets broke through in 1938, and sturgeon, soft clams, and mussels were abundant. Baymen sailed and poled their boats. They dried their nets on net reels like Fletcher Raynor's on Beaver Dam Creek, pictured here around 1908.

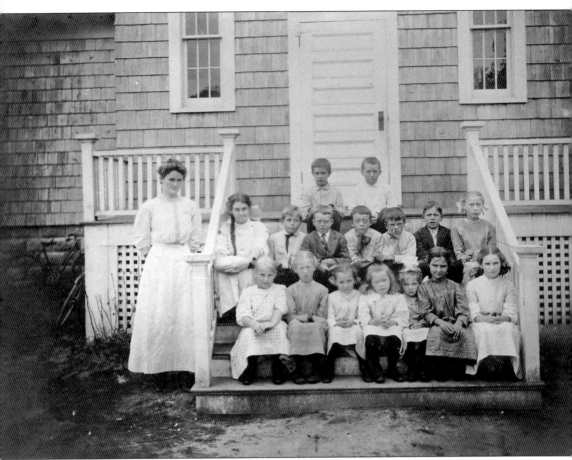

TANNER'S NECK SCHOOL. In the late 1800s, Beaver Dam's growing population necessitated the building of a second school, consisting of one room for six grades. The student body grew to 60 in number, still with only one teacher . . . until the day the students played cowboys and Indians at recess and tied the "cowboy," the teacher, to a tree and left. Shortly afterward, the school had two rooms and two teachers.

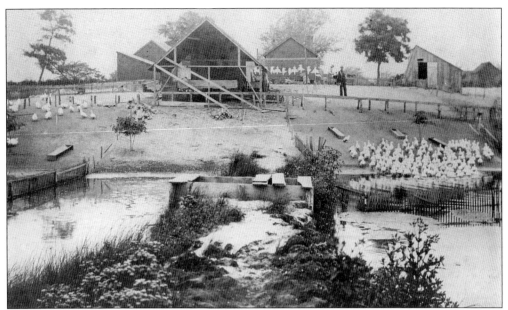

LONG ISLAND DUCKS. White Peking ducks first arrived on Long Island in 1885. With its humid climate, sandy soil, and abundance of creeks, the East End proved to be ideally suited for raising ducks. Within a few years, A. J. Hallock's Atlantic Farm on Brushy Neck Lane in Westhampton was the largest duck farm in the world, and restaurant menus around the world featured the delicacy known as Long Island duckling.

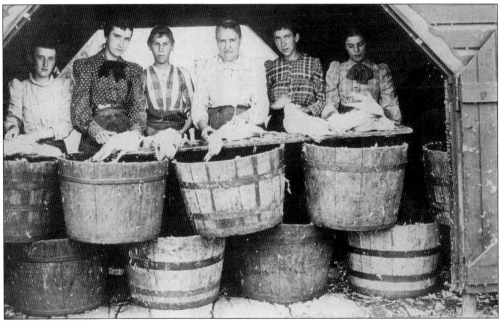

DUCK PLUCKERS. Small duck farms quickly proliferated along the waterways of Westhampton, along the Speonk River, Tanner's Neck Creek, Beaver Dam Creek, and in numerous coves along the South Shore. At one time, Atlantic Farm alone produced a quarter million ducklings a year. Women who were particularly proficient at picking duck feathers by hand could earn $5 a day at a time when farmhands made $1 a day.

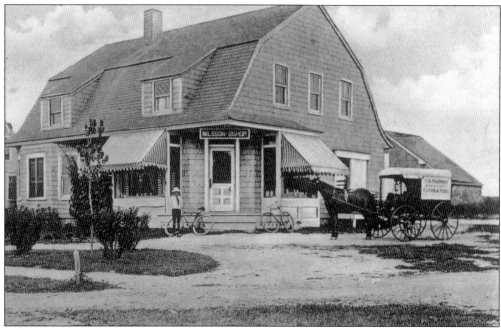

NILSSON AND BISHOP. While the main commercial district developed a mile southeast of Beaver Dam, Nilsson and Bishop opened a grocery store in the late 1800s at the junction of Baycrest Avenue and South Road. Ludvig Ehlers (1877–1952) operated Ehlers Grocery here until the 1950s, when the store became the Corner Grocery. In the 1980s, after serving for 100 years as a grocery store, the building became a private residence.

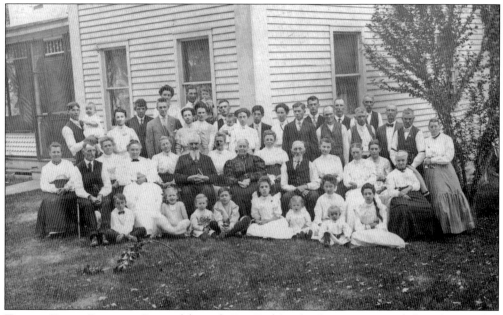

TUTHILL FAMILY REUNION. Some of the early East End families have maintained close almost tribal ties as their numbers increased over the centuries. Like the Raynors, the Jaggers, and the Halseys, to name a few, the Tuthills have celebrated their genealogy in periodic multigenerational reunions, such as this one held in 1900. Tuthills can still be found throughout the town of Southampton.

HOWELL STEVENS HOMESTEAD, C. 1985. Just as they did in Beaver Dam, cattle and sheep men built shelters in Catchaponack. Capt. Tom Stevens's original pre-1730 shepherd's hut could still be seen 250 years later, attached to the expanded house as part of the Stevens dairy farm. Cows grazed on pastures just off Main Street until the 1960s. The house remained in the Stevens' family until it burned down in 2000.

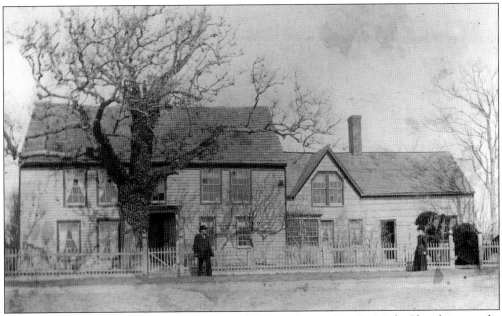

HOUSING THE REDCOATS. Built in 1740 at the end of Main Street where St. Marks Church is now, the Jessup homestead quartered British soldiers during the Revolutionary War. In this 1890s photograph, Isaac and Sarah Jessup appear in front of the house, which was taken down in 1914.

STAGECOACH STOP. The 1803 Griffing house served as a tavern and inn for stagecoach runs to New York. In 1826, the stagecoach left Sag Harbor at 6:00 a.m., breakfasted at Stephen Griffing's tavern, overnighted at Patchogue, and reached Brooklyn that night. Later a boardinghouse, it remains today as a private residence. Two wings that originally flanked the main building have been removed to serve as separate houses.

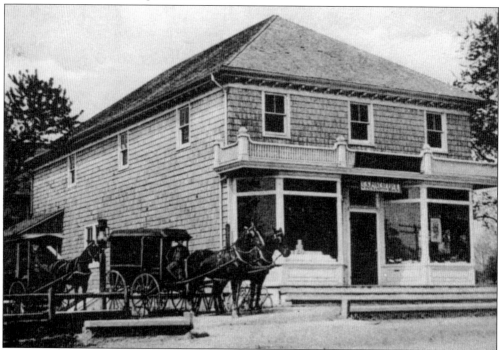

ERNEST BISHOP'S STORE. In 1903, Ernest Bishop opened his new general store on the north side of Main Street. The first Westhampton Beach Post Office opened in a corner of the store, and an upstairs room was used by a Riverhead barber who came every Saturday to attend to the village men. Owners after 1924 included Fred Newins, the Browns, and the Sextons.

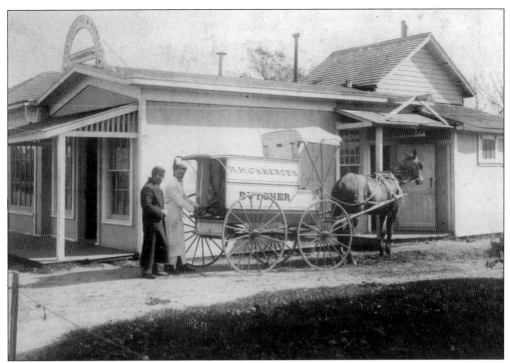

THE BUTCHER WAGON. In 1895, Camerden Market's butcher wagon traveled around the village delivering fresh meats and poultry to homeowners, many of whom had no means of transportation to get to the shops. In 1902, Moses Weixelbaum bought the business, and for the next 50 years he supplied local customers, as well as large hotels and boardinghouses, with groceries and fresh meats, fish, and poultry. "Moe" passed away in 1956.

THE BLACKSMITH SHOP, 1917. Andrew "Ward" Havens (1869–1935) was the village blacksmith for 40 years. His shop became the town meeting place and care center, where Ward kept a list on the wall of villagers in need. The sick received food and nursing help, and those with money trouble received cash from a little box replenished with contributions. Ward also sharpened all the children's ice skates for free.

VIRGINIA WILLIAMS, 1904. Main Street was still a dirt road when four-year-old Virginia Williams crossed over toward the "Little Red Schoolhouse," situated on the south side opposite what is now the Patio building. Built around 1861 with no central heating, the school had an outhouse, kerosene lamps, and a budget that included $288 for the teacher's salary, $4 for crayons and supplies, and $25 for schoolhouse repairs.

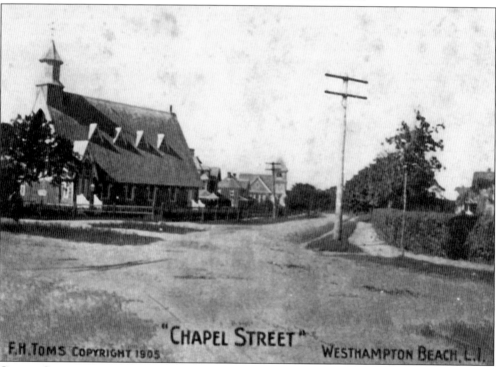

CHAPEL STREET, 1905. A community chapel used as a meeting house for both Episcopalian and Presbyterian services, the (1874) Union Free Chapel on the corner of Main Street and Mill Road belonged to the village. Beach Methodist Church to the right, dedicated in 1891, is possibly the oldest Westhampton church still in continuous use. The area's first Catholic church was built in 1899, and the Methodist Episcopalian Zion Church in 1901.

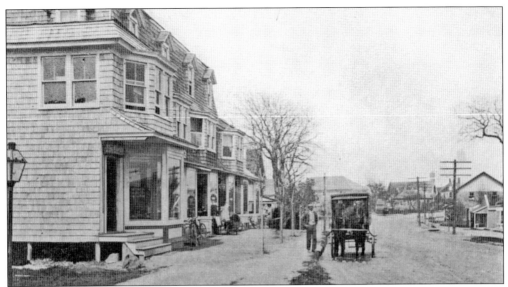

WESTHAMPTON COMMERCIAL CENTER, 1905. By 1905, the center of Westhampton's commercial life had moved from Beaver Dam to the village of Westhampton Beach, with its population of well over 400 residents. The village telegraph office opened in 1895, and a year later the Ladies' Village Improvement Society lobbied successfully for the installation of gaslights along Main Street. In the late 1890s, central heating became available.

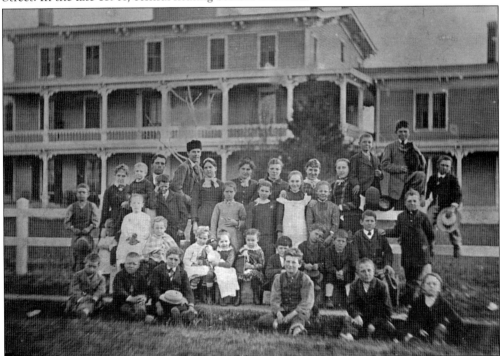

RED SCHOOL STUDENTS, 1881. Students from the Red School posed for a photograph in front of the community's first resort hotel, the Howell House, which was built in 1866. Until 1903, when the Union Free School (also called Six Corners School) was built, any student wishing to study beyond eighth grade had to travel by train to Patchogue to attend the Patchogue High School.

23

Turkey Bridge. Built across Aspatuck Creek in 1873 to carry Westhampton's East Main Street onto Quiogue, the bridge was named after turkeys from Maturin Delafield's farm that occasionally roosted on the bridge at night. Until the 1930s, most schoolchildren not only walked to school, sometimes more than a mile each way, but walked home at midday for lunch.

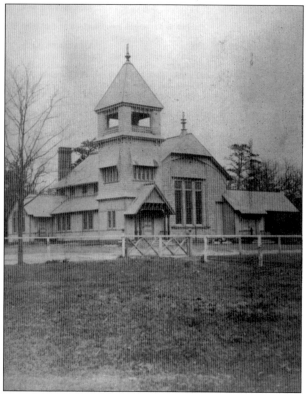

Westhampton Presbyterian Church. In 1832, a new Presbyterian church was built on Quiogue to replace the Beaver Dam church in order to be more centrally located for the congregation. In 1832, the land was sufficiently open that the beach could be seen from the church doorway. So many ministers lived on Quiogue that the area came to be known as the Holy Land and Quantuck Bay as Ministers' Bay..

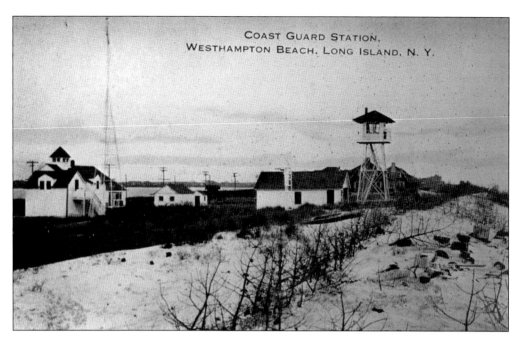

COAST GUARD STATION,
WESTHAMPTON BEACH, LONG ISLAND, N. Y.

POTUNK LIFESAVING STATION. Because of the number of shipwrecks off Long Island between Moriches and Montauk, Congress established the United States Life-Saving Service in 1878. Stations were built on the beach every 4 miles along the South Shore and were manned by "surfmen" equipped with dories and lifeline guns. They sought to rescue the grounded ships' crews before the vessels broke apart in the surf. Situated between West Bay Bridge and Gunning Point, Westhampton's Potunk Station was assimilated into the Coast Guard in 1915. It washed away in the 1938 hurricane.

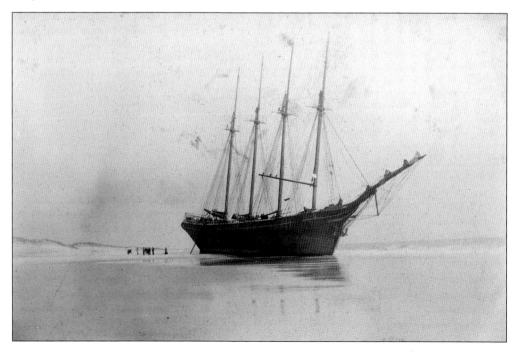

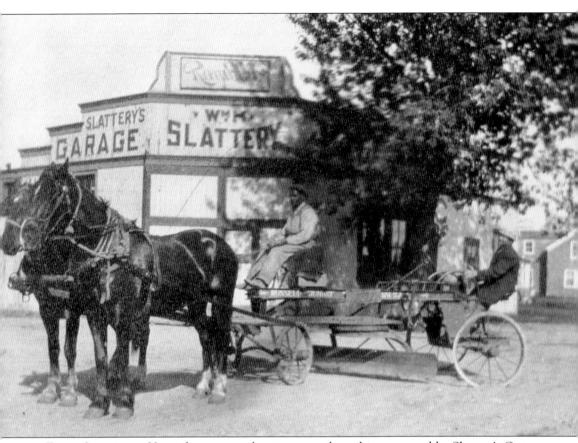

EARLY SNOWPLOW. Horse-drawn snowplow teams, such as this one posed by Slattery's Garage on Mill Road at Six Corners in 1901, were used in March 1888. A blizzard trapped most of the community in their homes for two days and two nights, leaving farm animals to fend for themselves. With drifts higher than the windowsills, residents were still digging themselves out two weeks later.

POSTMISTRESS, 1914. Mabel Stevens Williams, the Westhampton Beach postmistress from 1913 to 1921, is pictured here on Easter Sunday in front of the post office, which was located then in the west end of the Grimshaw building (today a real estate office) on the north side of Main Street. In 1914, mail came three or four times a day by train.

THE VILLAGE LAMPLIGHTER. C. Russell Raynor, accompanied in this 1905 photograph by his children Ann, Russ, and Phillip, lit all the village gas lamps by hand. The 1896 lamps were electrified in 1910 with a power line run from Long Island Lighting's Riverhead plant. Russell was also an amateur inventor, whose many creations included a wooden bicycle and a hammock-powered saw.

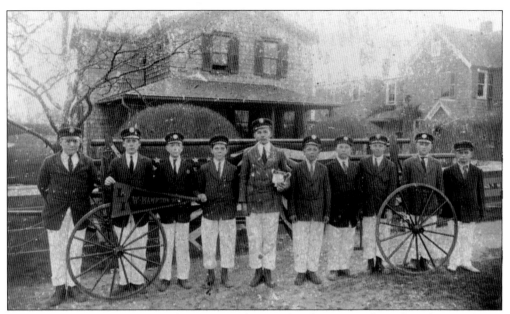

JUNIOR FIRE DEPARTMENT. Westhampton's volunteer fire department has a long history dating back to 1904 and includes junior firefighters-in-training, such as these pictured here. The first firefighters moved their equipment by hand, later by horse, and in 1922 by motorized fire engine. Once housed on Griffing Avenue, then on Glovers Lane, the main firehouse today is in a large building constructed in 1953 on Sunset Avenue.

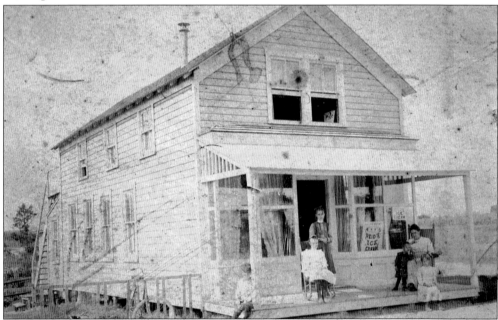

OCAME'S ICE CREAM. Closely identified with Quiogue's history, the Ocame family (Nicholas and sons Herbert and Everett) started a livery business that transported visitors to and from the boardinghouses, where they provided innumerable other services, including maintenance work and sailing parties. Herbert Ocame's wife, Lucinda, seated on the right with their children in 1900, opened Ocame's Ice Cream Store near Turkey Bridge to cater to the expanding summer trade.

Two

WISTERIA SUMMERS
1850 TO EARLY 1900s

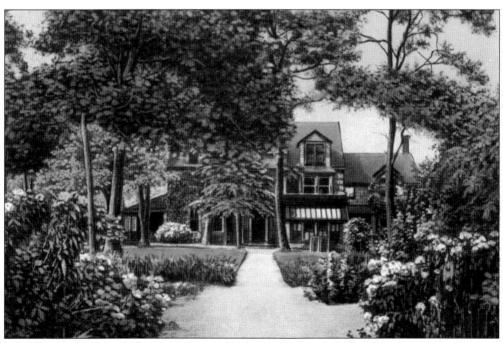

MARY FOSTER DOBSON'S HOMESTEAD INN. By the mid-1800s the Westhampton area had become popular with New York City residents seeking a quiet vacation by the seashore. Typical of the first boardinghouse hosts was Mary Foster Dobson, who began taking summer guests into the family's pre-Revolution farmhouse on Quiogue in 1874.

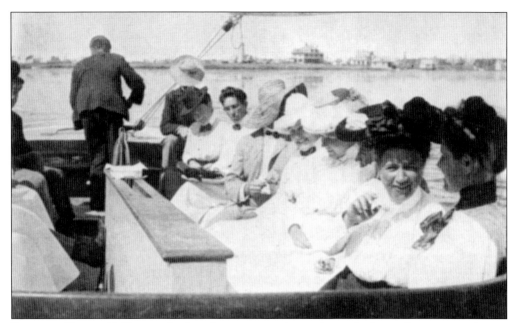

SAILBOAT FERRY. Sailing to the beach was a popular and speedy form of transportation as boardinghouse sailboats, such as the Homestead's catboat shown here in the 1890s with summer guest Professor Todd at the tiller, carried the vacationers across Quantuck Bay to the barrier beach for ocean bathing. Other sailboat ferries, such as Captain Jerry's in Moriches Bay, catered to waterfront boardinghouses on other bays.

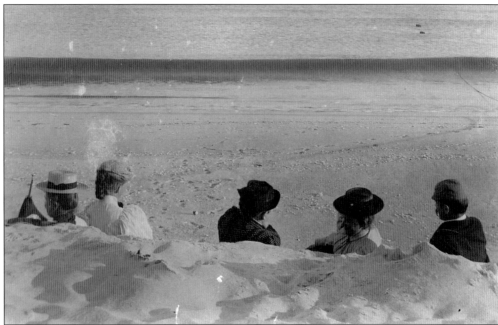

QUANTUCK BEACH, 1890s. Ocean bathing, sailing, duck hunting, cool sea breezes, and a moderate healthful climate, these were some of the attractions that originally drew urban and suburban dwellers out to the boardinghouses on the East End of Long Island. Just sitting in the sand and looking at the ocean was enough for these lodgers from the Homestead Inn on a summer day in the 1890s.

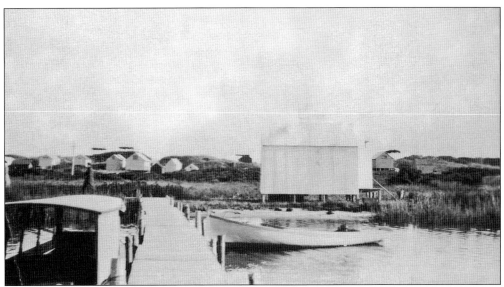

BEACHFRONT BATHHOUSES, 1915. The dunes were mostly uninhabited until the later part of the 1800s. The earliest oceanfront structures were rustic bathhouses such as these built by the Quiogue residents that were later incorporated into the Quantuck Beach Club. In 1870, William and Beulah Raynor opened the first public Westhampton bathing station, later known as Rogers Bathing Beach and now as the Village Beach.

THE CARTER FAMILY VACATIONING. Rest, sailing, ocean bathing, hunting, and church-going were high on the list of favorite summer activities at the Homestead Inn. Innkeeper Mary Dobson was known for her literary tastes, refined clientele, and hearty table fare. Among the earliest families to summer at the Homestead were Rev. Frederick Carter, an Episcopal minister from Brooklyn; his wife, Fanny; and their children, pictured here around 1900.

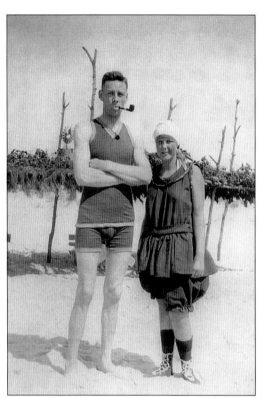

GILBERT AND ELIZABETH HALSTED. Vacationing families often returned to the same boardinghouse year after year, and many eventually built their own homes in the area, as did the Halsted family, who summered for years at the Apaucuck Point House before building a home in Remsenburg. Gilbert Halsted and his sister Elizabeth are pictured in 1918 wearing the fashionable, and supposedly modest, beach togs of the era.

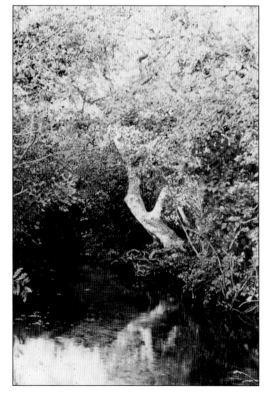

FAIRY DELL. Quantuck Creek ends at Old Country Road on Quiogue in a secluded glade named Fairy Dell, pictured here in 1910. Always a popular spot for fishing, canoeing, and spooning, the Dell was the spot where many courting couples sealed their engagement promises and carved their names into the bark of the so-called Initial Tree, shown here. Fairy Dell is now part of a wildlife refuge.

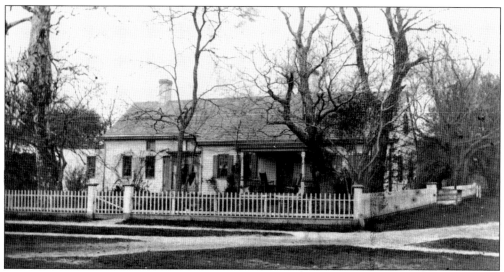

HOWELL HOMESTEAD. Built around 1727 by Hezekiah Howell, who, with Jonathan Raynor, was one of the first two Englishmen to buy land in Catchaponack, the homestead is one of the earliest houses in Westhampton Beach. P. T. Barnum, Noah Webster, and other celebrities stayed here in the 1860s as guests of Charles Howell. At one time, the Howells owned much of what is now eastern Main Street and Beach Road.

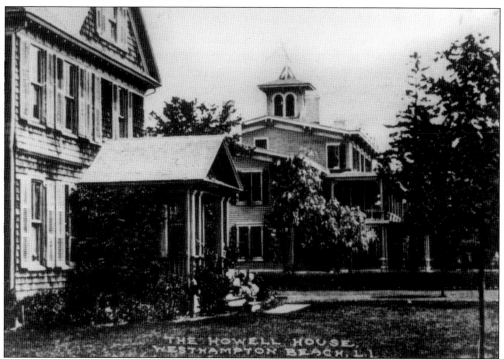

HOWELL HOUSE HOTEL. In 1865, P. T. Barnum helped finance Charles Howell's son Mortimer in the construction of Catchaponack's first summer hotel, visible to the right of Mortimer Howell's home, Restacre. The Howell House opened in 1866, and it was in one of the hotel's parlors that the Long Island Railroad decided—some say at Barnum's urging—to build the railroad line that would carry travelers directly from Jamaica to Westhampton.

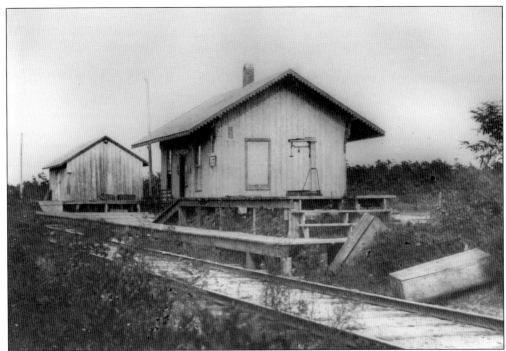

WESTHAMPTON'S DEPOT, BUILT 1879. Before 1869, visitors seeking to vacation in Westhampton took a train from Brooklyn to Riverhead and from there an uncomfortable one-hour ride by buckboard to the village. The first train pulled in to Westhampton on December 20, 1869, and by 1911, the railroad was carrying almost 35,000 people a year out to Long Island's East End. By then, Westhampton was an internationally known resort.

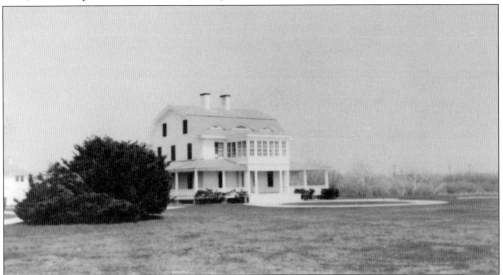

GOVERNOR DIX'S HOME. Despite prophecies that living close to the water would result in rheumatism, mildew, and hurricane damage, New York governor John Adams Dix, an ardent bird-hunter, built a country home on 50 acres off Beach Lane in 1870, a half-mile from the ocean. He established residency, and others quickly followed his example, building homes close to the ocean. The Dix home was taken down in the 1980s, when the building was in disrepair.

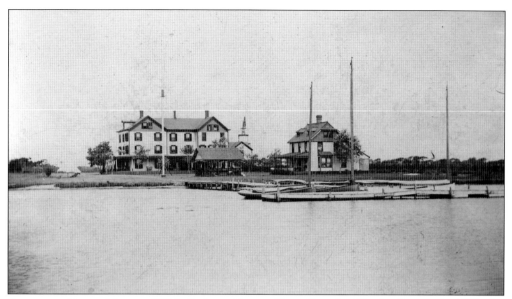

APAUCUCK POINT HOUSE, 1894. Built on Beaver Dam Cove by Charles Raynor in 1880, the Apaucuck Point House was one of the most popular of the bayfront hotels. It accommodated 60 guests and for $8 a week offered three meals a day (including vegetables from its own gardens), croquet and a hammock, a dock, sailboats and rowboats for rent, and transportation across Moriches Bay to Culver's Beach for ocean bathing.

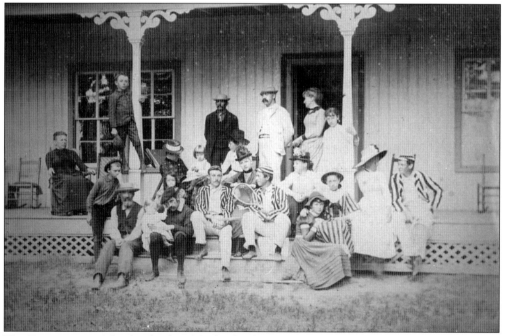

THE EVERGREENS. After her husband Seth's death in 1892, Mercy Gager Jagger turned their 1865 Westhampton farmhouse into a boardinghouse for guests, pictured here around 1906. The Jaggers built a second hotel named Cedar Beach nearby at the end of Jagger Lane on Moriches Bay. In 1969, that hotel was loaded onto a barge and towed west to Remsenburg, where today it is the Westhampton Yacht Squadron's clubhouse.

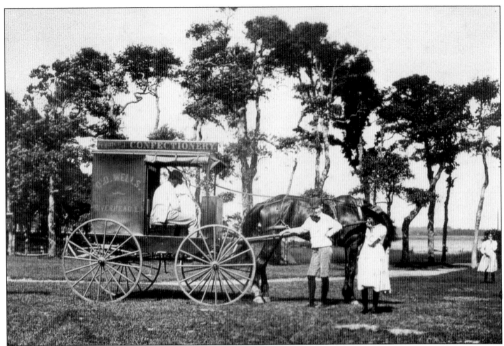

THE CANDY MAN. A Riverhead-based confectioner named O. O. Wells is shown selling sweets to Quiogue vacationers in 1915. Before automobiles became commonplace, vendors traveled around Westhampton selling food and dry goods from house to house. Vendors without a horse, like James Seeley in the early 1900s, pushed a handcart full of goods from Westhampton Beach's Main Street to hotels as distant as the Apaucuck Point House.

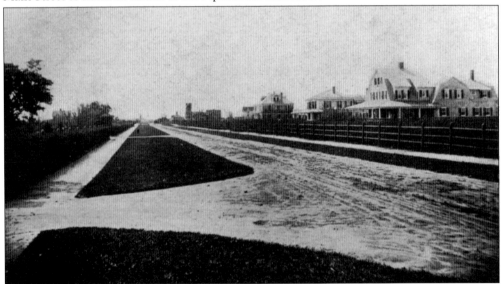

BEACH LANE, 1910. A telegraph office opened in the village in 1895, central heating became available in the late 1890s, and gaslights were installed on Main Street in 1896. By that date, the west side of Beach Lane featured the Westhampton Country Club's first clubhouse and a steel turnstile bridge joined Beach Lane to Dune Road, crossing the waterway that had been dredged between Quantuck Bay and Moriches Bay.

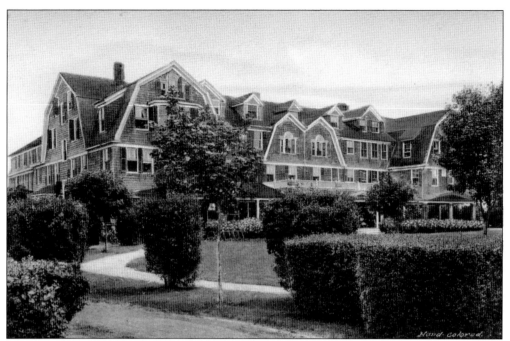

THE HAMPTON INN. By 1910, Westhampton Beach offered vacationers a choice of several large hotels, including the Hampton Inn (built in 1903 on Beach Lane by Stephen F. Griffing Sr.), the 1866 Howell House on Main Street, the 1867 Oneck House on Oneck Road, and the 1905 Moorland Hotel on Beach Lane. The economy of Westhampton was no longer based on agriculture and fishing but instead on summer visitors.

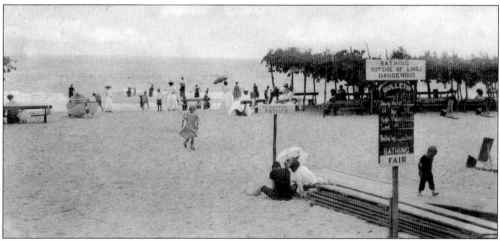

AUGUST BEACH SCENE, 1906. August 4, 1906, was a typical summer day on the beach: 78-degree air temperature, 70-degree water temperature, and fairly calm ocean conditions. Beach amenities included oak-leaf arbors, a lifesaving dory, and wooden beach seats. Ferries (first sailboats and later motorized power launches) provided the vacationers transportation to the beaches in the morning and in the afternoon, returning them to their boardinghouses and hotels for midday lunch.

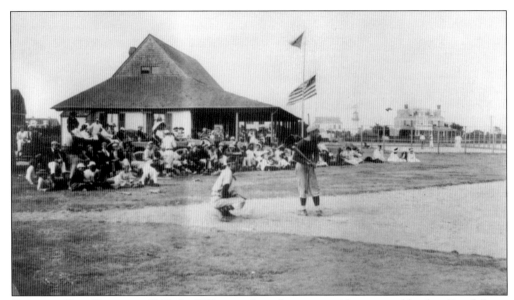

COUNTRY CLUB BASEBALL, 1910. In 1890, a number of summer residents rented land on Beach Lane and formed the Westhampton Country Club. Sports offered at the club included baseball, tennis, golf, sailboat racing, clay pigeon shooting, croquet, quoits, and horseshoes. The clubhouse interior featured silk pennants marking sporting victories over the Quogue Field Club, a large fireplace, and a dance floor for Saturday night parties. Tea was served every afternoon at 4:00 p.m.

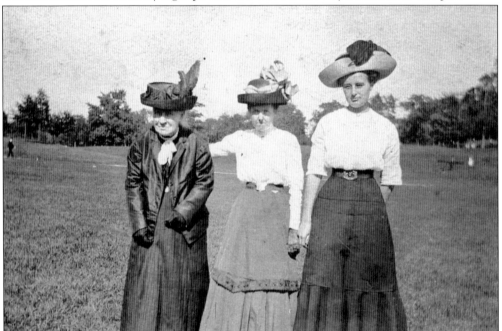

GOLFING SPECTATORS. The Westhampton Country Club built a nine-hole, par-34 course in 1896, on the southeasterly side of Quiogue on land owned by club member Sheppard Homans. Saturday night moonlight golf games were occasionally played, but for men only. Pictured here on the fifth tee around 1899 are, from left to right, spectators Frances Hulse, Nellie Hulse, and Lucinda Ocame. A new course was built on Beach Lane in 1902.

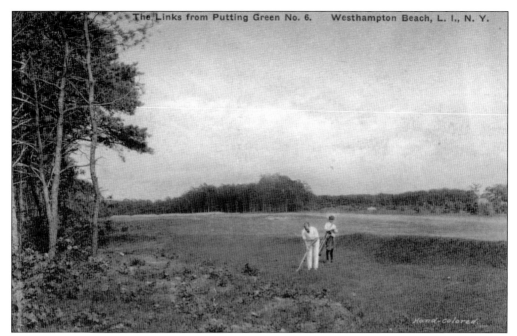

THE SIXTH HOLE. In 1915, the club moved to its current location on Potunk Lane, where a new clubhouse was built on the site of Nathan Jessup's boardinghouse, with an 18-hole course designed by Seth J. Raynor. Golf had been introduced to the United States in 1888 by John Reid, a native of Scotland living in Yonkers-on-the-Hudson, whose friend Robert Lockhart brought him some clubs from Scotland.

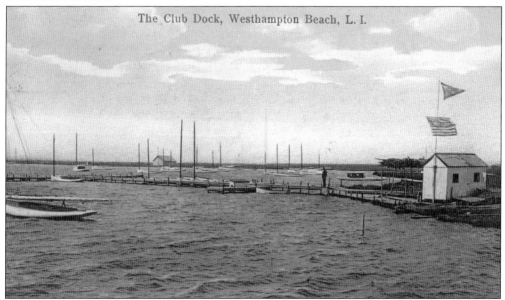

The Club Dock, Westhampton Beach, L. I.

CLUB DOCK, 1911. The original 1890 country club included this small yachting clubhouse and a dock on the shore of Moniebogue Bay. The Apaucuck Point House's dock was used for races until 1922, when a new clubhouse was built on Speonk Shore Road in Remsenburg. After that building was destroyed in the 1938 hurricane, the Westhampton Country Club dissolved its yacht club and the independent Westhampton Yacht Squadron was formed.

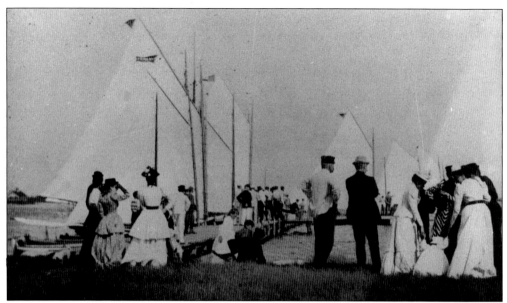

RACE DAY, c. 1900. Race day, whether here at the Quantuck Yacht Club or at the Westhampton Country Club's dock, was a scene of bustling activity. Bets were wagered on the outcome of the races, and crowds of spectators, including grandparents, parents, and children, spent the afternoon on the lawns and the dock, awaiting the outcome. Yachting classifications included the A boats, AAs, and BBs, with four- and five-member crews.

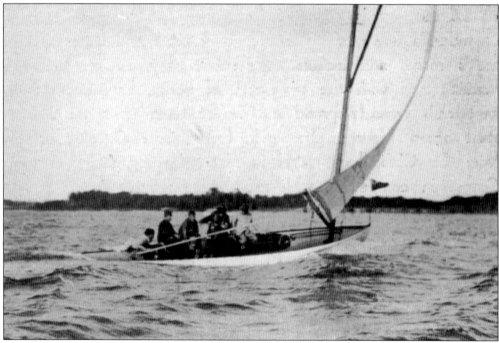

IN THE LEAD. A 28-foot AA class catboat rides the waves in this picture, taken around 1900. Among the five-man crew was often a navigator/tactician hired by the owner to advise the helmsman. The AAs' golden age lasted from about 1900 to the start of World War I, after which the sailors had difficulty finding the five people necessary to make up the racing crew.

WILLIAM AND IDA ATWATER. William Cutler Atwater (1861–1940) was an avid sailor in the early 1900s. President of several coal and railway companies, he served at different times as the commodore of both the Quantuck Yacht Club and the Westhampton Yacht Club. His BB class *Billy Boy* was the inspiration for a smaller, 16.5-foot sailboat called the SS class, which Atwater helped design in 1908 for children to sail.

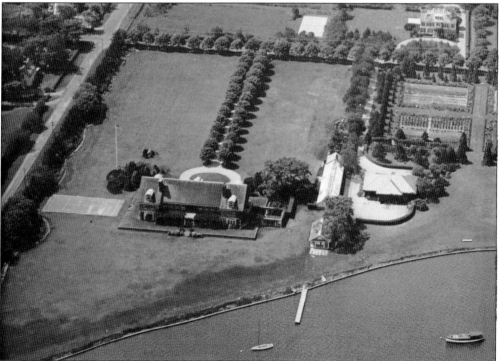

THE ATWATER ESTATE. In 1904, William Atwater built a summer home in Westhampton Beach on the shore of Quantuck Bay. Designed by Henry Bacon (architect of the Lincoln Memorial), the house included eight family bedrooms, numerous servants' bedrooms, a garage with room for seven cars plus an apartment for a chauffeur, a very large greenhouse, extensive gardens, and a boathouse where generations of sailors have gathered to swap sailing stories.

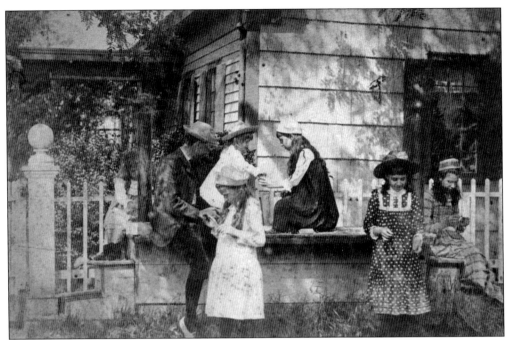

THE HORSE BLOCK. In 1900, most every hotel and boardinghouse around Westhampton had a horse block like this one at the Howell House to aid its guests into the saddle or into a carriage. Horse blocks were also comfortable gathering spots for a variety of activities, but very shortly they would not be needed any more.

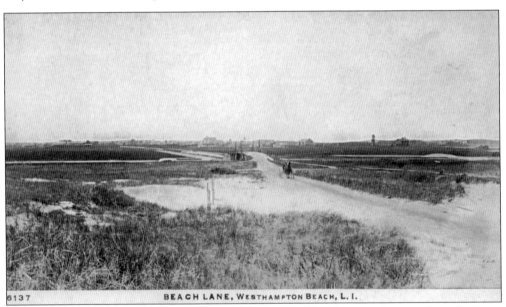

6137 BEACH LANE, WESTHAMPTON BEACH, L. I.

THE END OF CATCHAPONACK. In 1900, around the time this photograph was taken of a horse and buggy crossing over the Beach Lane bridge to the sandy barrier beach, vestiges of the old Catchaponack could still be seen. Cranberry bushes still grew on the oceanfront dunes, and the roads were covered with sand and dirt. But the arrival of the automobile was about to change this seaside scenery.

Three

Tires and Wires
1900–1925

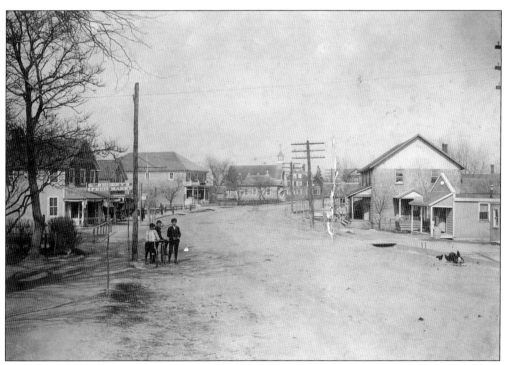

Main Street, 1904. From left to right, Milton Schrann, Willard Smith, and Howard Havens stand in 1904 on a main street lined with stores, a church, a school, a telegraph office, and a hotel. But chickens still roamed freely, pecking at horse droppings, and the boys raced goats through the middle of town on Sundays.

FIVE POINTS. The corner of Mill Road (left) and Oak Street in 1905 was still a place where children could play without any shoes and pretend to be Native Americans. Community amenities, however, included a newspaper (the *Hampton Chronicle*, 1906), a fire department (1904), the wireless telegraph (1895), the Water Company (1898), and even a Lying-In Hospital in a former boardinghouse on Linden Lane just east of Turkey Bridge.

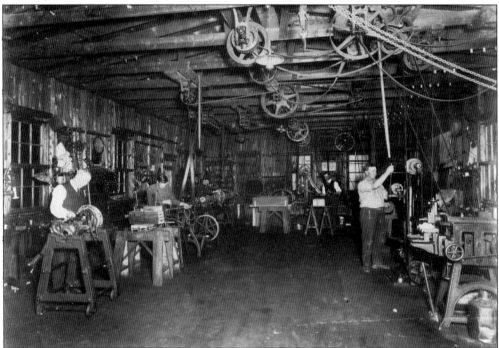

SLATTERY'S MECHANICS. In 1907, Will Slattery established a machine shop at Five Points that catered to the growing industry of new-fangled inventions, such as the Waterman Outboard Motor. Slattery specialized in made-to-order machinery, advertising with the slogan, "If it's made of metal, I can make it." As the number of "horseless wagons" increased, Will Slattery changed the name of his shop to Slattery's Garage and made room for 25 cars.

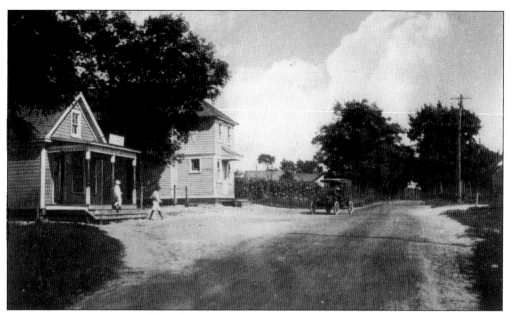

DRIVE-UP POST OFFICE. By the early 1900s, a steam-engine train dropped mail at the Westhampton depot three or four times a day (supplanting the long-ago pony express rider who had dropped letters into the hollow of a tree at Beaver Dam). The mail was picked up by automobile and delivered to post offices like the Westhampton (Beaver Dam) Post Office on Mill Road, next door to the American Legion.

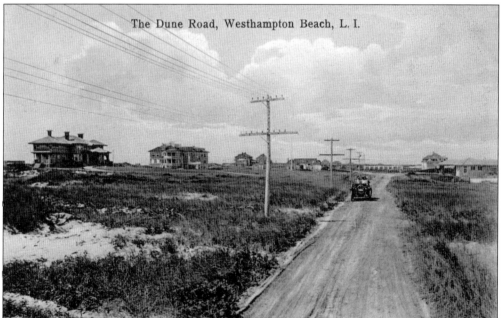

TOURING DUNE ROAD. With the advent of automobiles, a road was constructed along the barrier beach, with the first segment stretching from Beach Lane east to Quogue in 1905. Dune Road now featured an automobile roadway suitable for the popular Maxwell car, the Stanley Steamer, and the Pierce Arrow. The resort town quickly became known, in addition to ocean bathing, sailing, and golf, for the pastime of automobile touring.

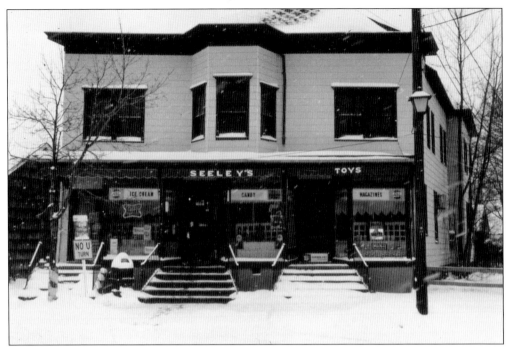

SEELEY'S. James Seeley (1869–1951) lived with his wife, Angelina, and their six children above their store, pictured here in 1982. One of the oldest in the village when they bought it in 1904, it originally had a white balcony around the second floor and was elevated with a high staircase because of occasional flooding from Moniebogue Creek. The Seeleys' youngest child, Gloria (1912–1984), took over the store in the 1930s.

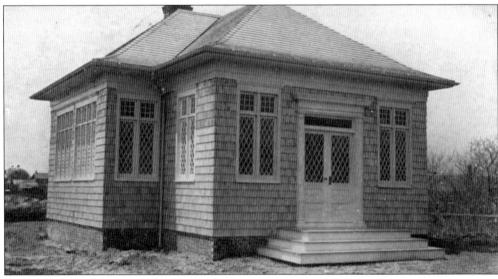

WESTHAMPTON LIBRARY, 1906 The Westhampton Free Library was first housed on the second floor of Egbert Smith's grocery store with books donated by residents and summer visitors. In 1906, it moved into its own building on Library Avenue. Expanded five times with the help of a trust fund established by Judge Harold Medina, the building was torn down in 2008 to make way for the construction of a new library.

Gussie Meeker, Librarian. Augusta Meeker (1869–1957), the village's first librarian, is pictured here in front of her family's 1735 homestead, which survives today on the grounds of the historical society on Mill Road. A teacher by training, Gussie established the library's procedures for book selection, purchasing, and cataloguing. Librarian from 1904 to 1937, she would be astounded by the village's new 2010 technologically savvy, energy-efficient, green library.

The Union School. In 1903, the Union School opened at Six Corners, providing grades 1–12. Prior to this time, students continuing education past elementary school had to go away to boarding school or take a 7:00 a.m. train to Patchogue, returning on the 6:00 p.m. evening train. Six Corners graduated its last class in 1939, when a new high school opened on the corner of Mill Road and Oneck Lane.

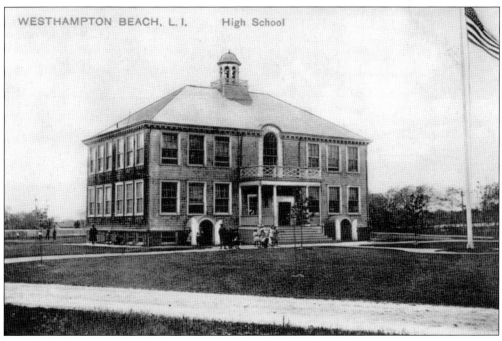

WESTHAMPTON BEACH, L. I. High School

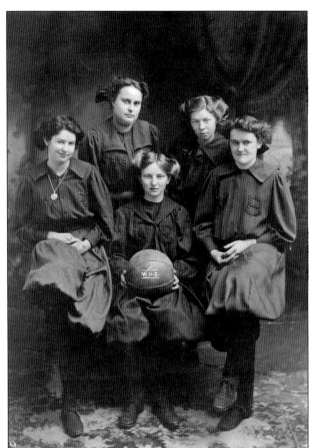

GIRLS' BASKETBALL, C. 1904.
The new high school offered athletic competition against other area schools, as shown in this photograph of the girls' varsity basketball team. Members of the team pictured here are, from left to right, (first row) Genevieve Halsey Raynor, Lucy Liedtke Bishop, and Amy Stevens Halsey; (second row) Madeline Ocame and Alice Young Greenwood. Most students already had a built-in exercise program, in that they walked to and from school with an additional round-trip home at midday for lunch.

BOYS' BASEBALL 1907. The Westhampton Beach High School boys' baseball team is pictured here around 1907. Bill Hulse, second from left in the first row, went on to become the village of Westhampton Beach's first mayor in 1928. In just a few years, some of these boys would leave their Long Island homes and travel abroad to fight in World War I.

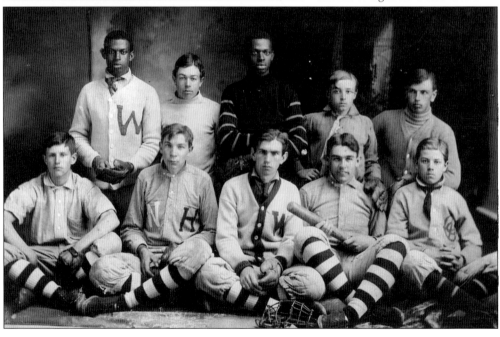

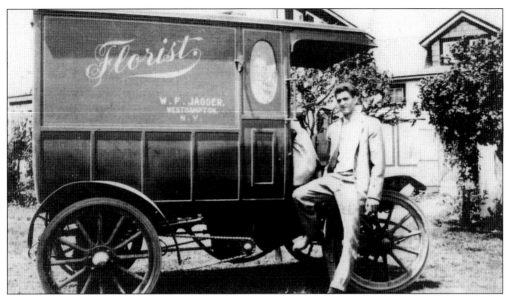

FLOWERS BY WHEEL. The flower industry was a thriving business in the early 1900s. Located on South Road near Tanner's Neck Lane, Willard F. Jagger's greenhouses supplied cut flowers and bedding plants to many of Westhampton's estates. Willard's nephew Harold Beecher Halsey Sr., pictured here with the company's new delivery truck, is about to take over the steering wheel, rather than the reins, for a delivery.

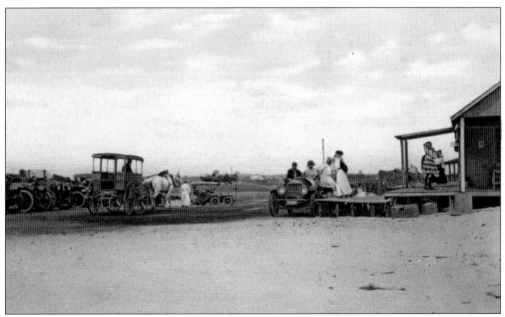

CULIVER'S BEACH. With the paving of Dune Road, Culver's Beach, founded in 1880 on the western end of the barrier beach and formerly reached primarily by sailboat, was now easily accessible by automobile and horse and buggy. In 1925, the Culver family sold the property to John Cook, who incorporated it into the Buena Vista residential development, which was largely destroyed in the 1938 hurricane.

D. Egbert Smith. In this early-1900s picture, Westhampton's wide Main Street could still accommodate both automobiles and horse-drawn vehicles. D. Egbert Smith stands by his delivery wagon in front of his grocery store, which was located on the corner of Glover's Lane. Smith hosted a graduation party at his home each year for high school seniors and their families, following the commencement exercises.

Main Street Looking West. In 1910, the country club and St. Mark's Church were not yet at the western end of Main Street, which remained the site of the Jessup farm. The Seeleys' store still had its second floor balcony, and James Seeley was still pushing his fruits and vegetables cart around to area boardinghouses as far away as the Apaucuck Point House, almost 3 miles from Main Street.

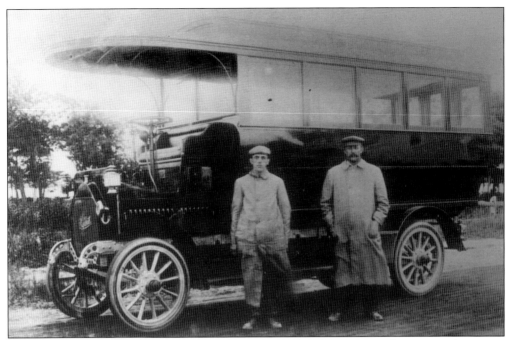

RAILROAD STATION TAXI. Sidewalks were often paved before the roads were because residents were slow to give up horses. Not so for the Ocame family, however. Their livery business flourished. They traded in their horse-drawn wagons (which originally required two round-trips to the train depot, one to carry passengers and a second for the luggage) for newer and larger versions of the original auto stage. Leonard Ocame is on the right.

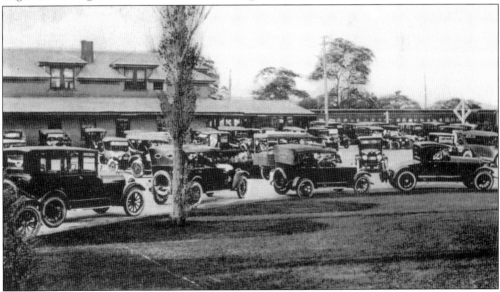

SUMMER FRIDAYS. Friday afternoons at the Westhampton train depot in the 1920s looked very much as they do today, as those fortunate enough to be spending the summer in Westhampton flocked to the depot at 5:45 p.m. to meet weekend visitors arriving on the *Cannonball* out of New York City. In 1923, railroad brochures promised "joy in store for all who tour the Sunrise Trail" of eastern Long Island.

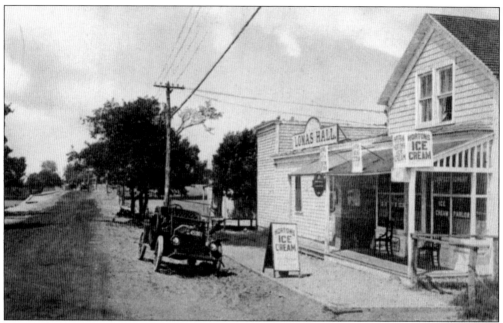

Lomas Hall. In the 1920s, Margaret and George Lomas took over the ice cream parlor just east of Turkey Bridge, together with a dance hall next door. A big room with a stage, Lomas Hall catered specifically to the summer help and to the "pot wrestlers" (as in chamber pots). A teetotaler, Margaret allowed no strong drink, but featured musical entertainment that included the latest in jazz and ragtime.

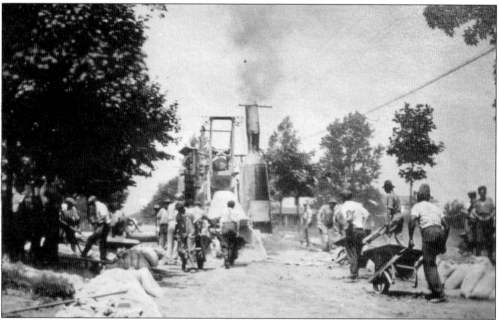

Paving the Roads. With the appearance of automobiles in the Westhampton area around 1900, some of the village roads were oiled for motorized traffic as early as 1902. By 1910, highway status had been granted to Dune Road from Quogue west to the West Bay Bridge, and work continued west 1 mile every year. Concrete paving was laid on Mill Road in 1918 and on Main Street in 1925.

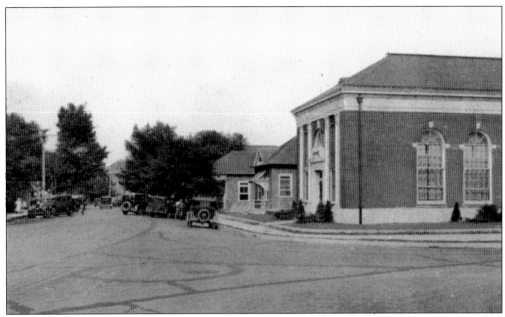

MAIN STREET, 1920. By 1920, about the time of this photograph, more automobiles than horses were used for village errands. Westhampton Beach's first real post office (today the Post Stop Café) opened in 1914, next to the 1904 Seaside Bank (the Bank of New York today, in a greatly enlarged building) and the 1874 Union Chapel, which was moved to Library Avenue in 1924 and later converted into a Dune Road residence.

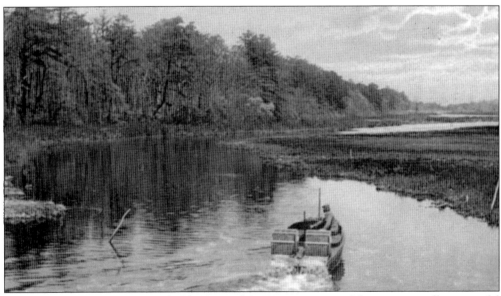

CRUISING BY MOTORBOAT. With Ole Evinrude's 1911 invention of the commercially successful outboard engine, motorboats like this one cruising on Beaver Dam Creek joined the sailboats on the waterways around Quantuck and Moriches Bays. The name Catchaponack had changed, too, transitioning to Westhampton in 1880 and to Westhampton Beach in 1890. In 1928, the 3-square-mile area known as Westhampton Beach was officially incorporated as the Village of Westhampton Beach.

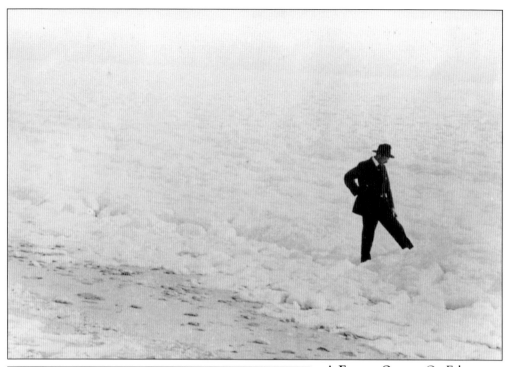

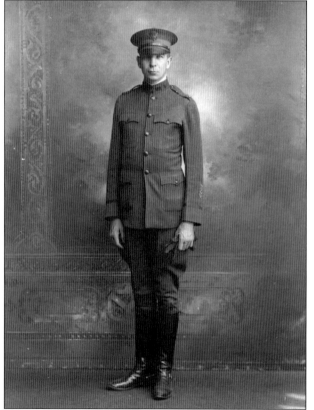

A FROZEN OCEAN. On February 7, 1918, the Atlantic Ocean froze so hard that George E. Winters could walk on it off Rogers Beach. The schools closed so that students could see the solid mass that extended out as far as the eye could see. Previous Westhampton climate oddities included no rain from May until November in 1762 and, in 1816, snow in June and ice in July and August.

LIEUTENANT HULSE. On April 6, 1917, after Germany sank the British transport ship *Lusitania* and resumed unrestricted submarine warfare off the eastern coast of America, the United States declared war on Germany, joining Britain, France, and Russia in World War I. Lt. William T. Hulse was one of the many soldiers from Westhampton who left the peaceful beaches of Catchaponack for the battlefields in France.

Four

A PEACEFUL INTERLUDE
1919–1938

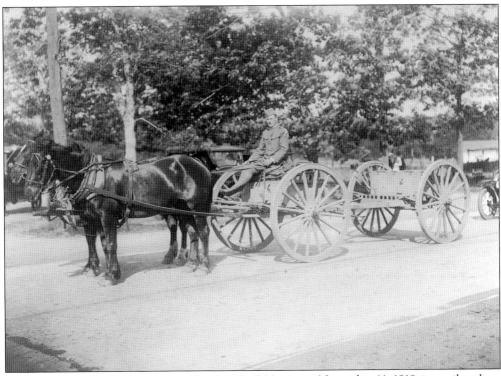

THE CAISSONS PARADE DOWN MAIN STREET. At 5:00 a.m. on November 11, 1918, in a railroad car parked in a forest in France near the front lines, an armistice agreement was signed, effectively ending the Great War after four years of fighting and the loss of more than 15 million lives.

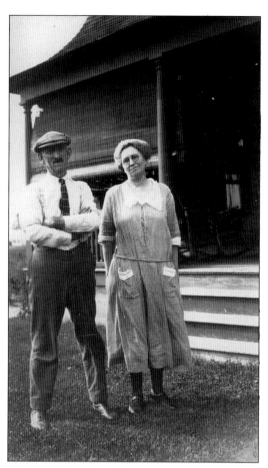

AUGUSTUS AND GRACE RAYNOR. Gus and Grace Raynor had been preparing for the end of the war long before the caissons and the troops paraded triumphantly down Main Street. In anticipation of the return of their sons, Cliff and Norman, from the battlefields abroad, Gus and Grace established a family business, Raynor's Garage, on Library Avenue. The family continued to run the garage for the next 40 years.

RAYNOR'S GARAGE, 1936. Founded in 1919, the garage was a dealership for Dodge and Plymouth cars and ChrisCraft boats. In the 1920s, Raynor's also garaged the Vanderbilts' coaches overnight as the family traveled, complete with footmen and teams of white horses, to summer homes further east. In 1956, the Raynor family sold the garage to Bill and Dode Hulse, and in 2005, it was razed.

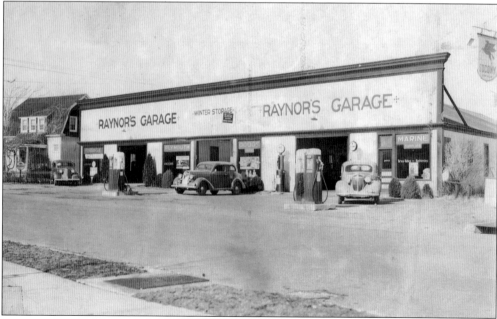

CLIFFORD RAYNOR, 1918. A village trustee, board of education president, and fire department chief, Cliff (1893–1953) worked exclusively at Raynor's Garage after returning home from the war. A bayman with a keen nose for weather changes, he was one of the few who anticipated the 1938 hurricane, lining up the garage's inventory of cars and urging anyone who passed to take a car and head for high ground in Riverhead.

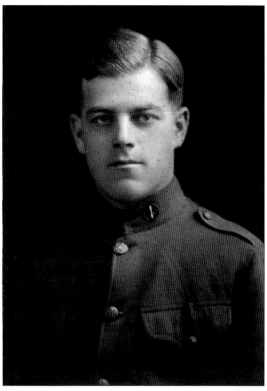

GENEVIEVE HALSEY. Reputed to have been one of the most beautiful girls in the village, Genevieve (1890–1969) married Cliff Raynor, thereby joining two of Long Island's oldest families. She was said to have been the first woman in Westhampton Beach to drive an automobile, so the two young people seemed particularly suited for one another.

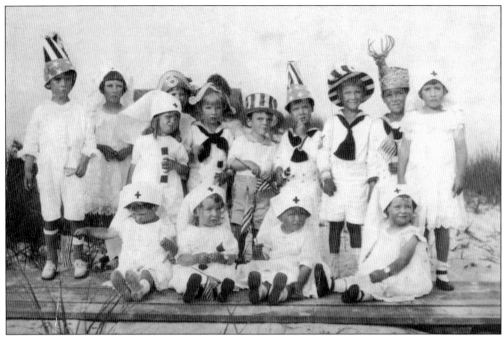

PEACE PARTY, 1920. A group of young nurses-in-training and beardless Uncle Sams celebrated a summer of peace with a sandy beach party alongside the Atlantic Ocean. Fears of U-boats and foreign invasions were just a memory.

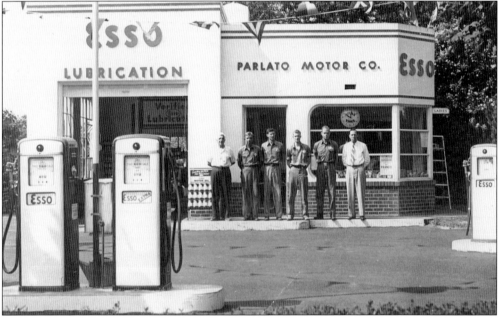

PARLATO MOTOR COMPANY. Competing with Raynor's Garage was Parlato Motor Company, a Chevrolet dealership founded by Mike Parlato (1888–1963). The garage later became the Marakesh nightclub and today is the Hudson Bank. The Parlato home, once the original garage, is now Starr Boggs Restaurant. Shown in this *c.* 1940s photograph are, from left to right, Mike Parlato, Bubby Culver, Charlie Lomas, Dinky Gordon, Fiske Reynolds, and Dick Wicks.

SONS OF THE BEACH. Posing in front of the old firehouse on Glovers Lane in the 1930s are members of the Westhampton Fire Department (nicknamed "Sons of the Beach"), from left to right, Clarence "Eggie" Raynor (kneeling), Bill "Weeze" Allen, Adam "Junie" Novick, Wilson "Pete" Nichols, Harold Halsey, Leslie "Dave" Warfield, Louis or Thomas Tomaszewski, Ralph Kirby, Bill McGonigle, Dan Ocame, Theodore "Dode" Hulse, Bill Hulse, Dick Lashley, and Demarest "Demy" Vickers.

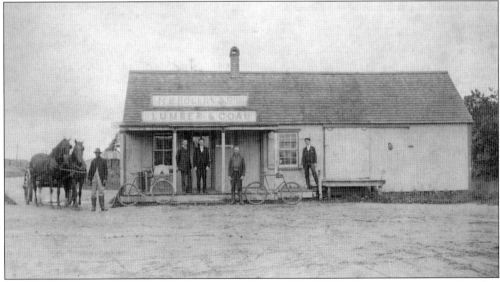

N. B. ROGERS. One of Westhampton's essential commercial concerns was Byron Rogers' Lumber and Coal Company, which distributed coal and building supplies throughout the community. The company was still in existence in the 1980s.

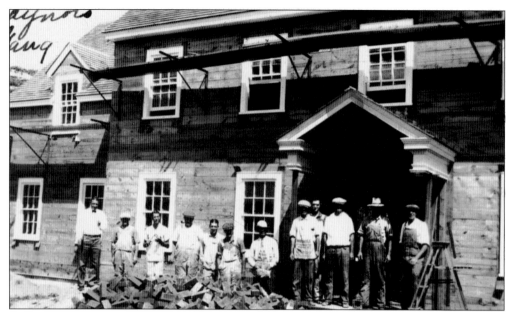

E. Raynor's Sons. The crew of E. Raynor's Sons, a contracting and building concern founded by Elijah Raynor around 1880, gathered for a company photograph in the 1930s. Elijah's grandson Madison Raynor, far left, was the third generation of his family to head up the company, which was located on the east side of Library Avenue. E. Raynor's Sons built many of the structures in Westhampton, some of which are still standing today.

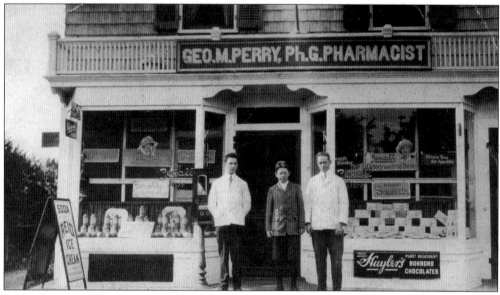

Perry Pharmacy, 1914. Main Street in 1914 was still a dirt road, with chickens and goats wandering on the empty lots between storefronts. Situated on the former site of Raynor and Bishop's General Store (1880–1902), Perry's sold pharmaceuticals and tonics, soda fountain concoctions, and the early postcards that have recorded much of Westhampton's history. The pharmacy became Sheeley's Drug Store in 1943 and is today a clothing store.

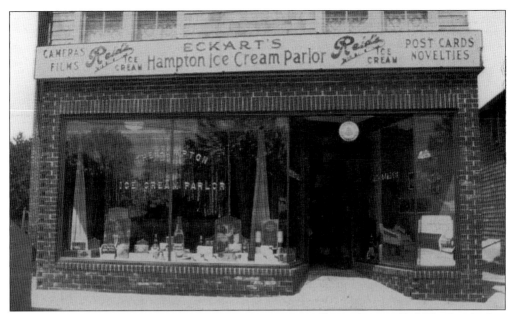

ECKART'S HAMPTON ICE CREAM PARLOR, 1930S. Originally a saloon called The Inside Out because of the shingled interior, Eckart's was the 1911 creation of Jacob Eckart. As an ice cream parlor/luncheonette, the store became a hangout not only for high school students but also for area politicians and small groups of friends like the Boys from Booth Four, who gathered daily for breakfast at 7:30 a.m. for more than 20 years.

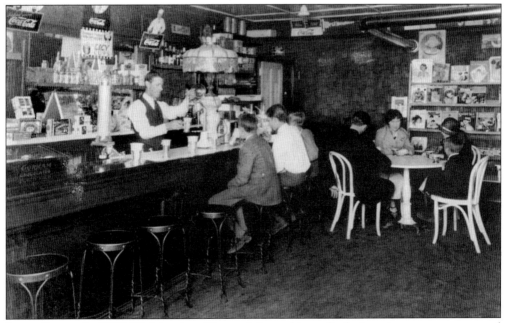

INSIDE ECKART'S, 1927. With its tin ceiling and glass cabinets displaying vintage newspapers and magazines, the interior of Eckart's Luncheonette today is relatively unchanged from its earlier days. In 1949, Jacob Eckart (behind the counter) passed the shop over to his son Warren ("Red"), who maintained a box on the counter filled with money that kids could borrow from, no questions asked. They always paid Red back when they said they would.

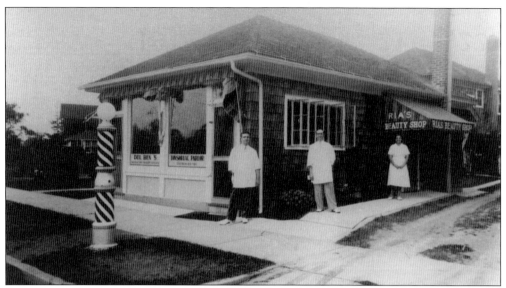

DEL BENE'S TONSORIAL PARLOR. Dominic Del Bene (1892–1985) came to America at age 17 and, in 1927, opened a barbershop in Westhampton Beach. Because of the Depression, his daughter Ria gave up her dream of being a teacher and, in 1939, joined her father and brother Danny in the family business. She offered women a shampoo, wave, and manicure for $1. Pictured in 1939 are, from left to right, Danny, Dominick, and Ria.

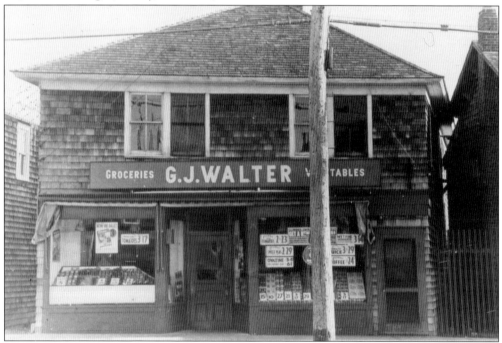

WALTER'S GROCERY STORE. Before modern supermarkets came to Westhampton, Main Street's grocery stores—like Walter's Grocery (pictured here about 1940), Weixelbaum's Market, D. Egbert Smith's, and Ambrosino's—were small and specialized, but most featured personal service and home delivery. Walter's was situated on Main Street across from Seeley's and was managed by Gelston Walter for more than 30 years, from the late 1930s until 1969.

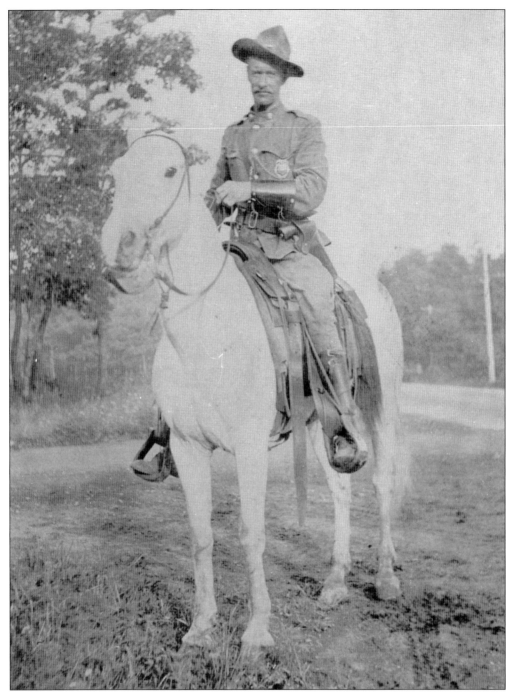

CONSTABLE EAGER, 1931. Alexander Winfield Eager (1878–1959) was Westhampton's one-man police force for years. He could pick up a handkerchief off the ground while on a galloping horse but turned down a role in a Will Rogers movie, saying he had found the world outside Westhampton to be unfriendly. When his gun was taken away (possibly because of one too many shoot-in-the-air charges down Main Street after tippling), he carried pliers in his holster instead, explaining, "You never know when pliers might come in handy."

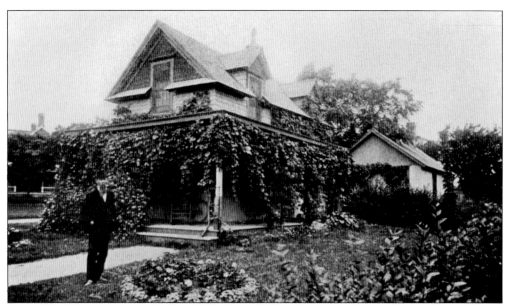

WESTHAMPTON DOCTORS. In the late 1800s and early 1900s, Dr. J. D. Brundage treated patients at his vine-covered house on Main Street, opposite where the Performing Arts Center is today. In 1907, Dr. Noah Wadhams (1875–1929) moved into a large white house at the corner of Potunk and South Road (now the South Winds Bed and Breakfast) and for 22 years was the only year-round doctor in town. He was a much-beloved medical Robin Hood who overcharged some patrons, telling them that was the only way he could afford to treat others, like Win Eager's 12 kids, for free. Doc Wadhams died during a supposedly routine tonsillectomy. The day before the operation, Doc gave Win a receipted bill to prove the Eagers owed him no money. The house was later owned by New York governor Al Smith.

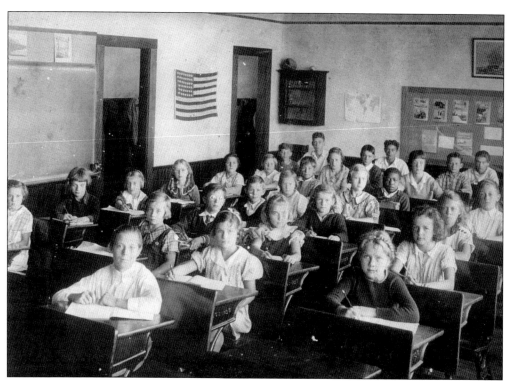

Two-Room Schoolhouse, c. 1934. By 1930, Westhampton's Tanner's Neck School had been expanded to two rooms with two teachers. Fourth through sixth grades are pictured here, while the younger students are in the other room. The school, located on Montauk Highway just west of Tanner's Neck Lane, is a private residence today. For grades 7–12, the students moved over to the Westhampton High School.

The Class of 1922. Westhampton High School graduated five students in the class of 1922. Pictured from left to right are (first row) C. Ludder Jr. and John Tourgee; (second row) Merton Van Cot, Naomi Martin, and Jesse Weixelbaum. In the yearbook, Naomi listed her ambition as "to pass physics," which she did. She became a nurse and worked with Dr. Noah Wadhams at the Lying-in Hospital on Linden Lane.

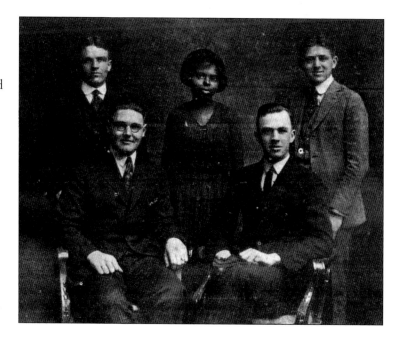

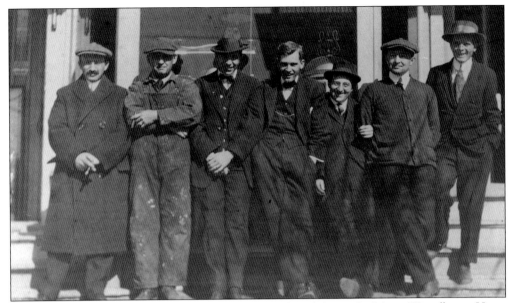

VILLAGE BUSINESSMEN. Posing happily in the 1920s are, from left to right, Moses Weixelbaum, Harry Culver, Bill Hulse, Bill Larabee, Clarence "Okie" Overton, John King, and "Doc Eddie" Smith. Most of these otherwise hardworking businessmen whiled away free hours sitting in the afternoon sunshine on a particular green bench outside Okie's jewelry store, thus earning membership in the exclusive Charter Members of the Westhampton Beach Green Bench Association.

PINEWOLD PARK. In 1906, Theophilus Brouwer (1864–1932) built a castle and a pottery factory on the shores of Beaver Dam Creek and decorated 28 acres with imaginative sculptures. He became one of America's foremost ceramic artists, and samples of his iridescent pottery are in the Smithsonian Institute today. In 1930, Angelina and Louis Basso bought the property and opened an Italian restaurant in the space formerly occupied by Brouwer's kiln.

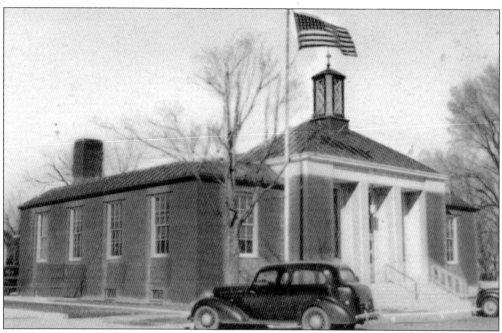

NEW POST OFFICE. Westhampton Beach's first single-use post office was the Post Stop (1914–1940), on the site of today's Post Stop Café restaurant. But in 1940, the U.S. Post Office moved east into a new building, for the first time occupying space built exclusively for handling mail. It is still the community's post office today. The lobby features a colorful wall mural depicting the village's sporting life attractions.

THE RAYNOR HOMESTEAD. "Big John" Everett Raynor (1864–1917) managed the Apaucuck Point House for 13 years, until his death at age 53. His wife, Mabel, and daughters Sarah, 5, and Betty, 3, returned to the Raynor homestead to try to eke out a living working the 100-acre farm by themselves. Although Mabel's family never forgave her for acting "like a common laborer," she managed to send both girls to college.

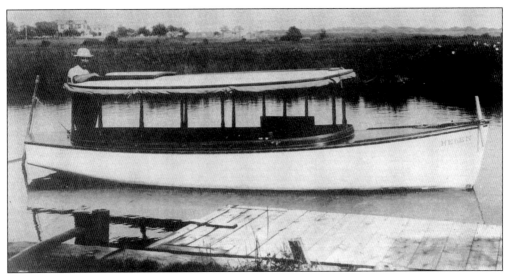

ARTHUR H. RAYNOR, C. 1900. A commercial fisherman, Arthur (1868–1947) is pictured on Beaver Dam Creek in his 24-foot beach ferry *Helen*. The Depression years were so difficult in the mid–1930s that when a shipment of clams (a full day's work for two men) did not bring enough at auction to pay the freight bill, many fishermen, including Arthur's son Daniel, were forced to leave Westhampton to seek work elsewhere.

ARCHIE WILSON RAYNOR, C. 1932. Archie (1875–1950, on left) had a prosperous duck farm on Tanner's Neck Lane before a disease killed his ducks and he lost his house and farm. Following the death of his wife, Grace (far left), in 1940, he built a four-room bungalow and eked out a living selling vegetables, homemade pies (including blackbird pies), flowers, imaginative wooden scarecrows, eel pots, and baskets from a roadside stand.

JAGGERS OF JAGGER LANE. With the coming of summer, the boardinghouses and hotels of Westhampton filled with vacationing guests. In this 1925 photograph, from left to right, Mary Townsend Jagger, Archer Jagger Jr., and Helen Jagger sit on the bayside beach in front of their family's Cedar Beach Hotel. The property was sold in 1969, and the hotel was towed down Moriches Bay to Remsenburg to become the Westhampton Yacht Squadron's clubhouse.

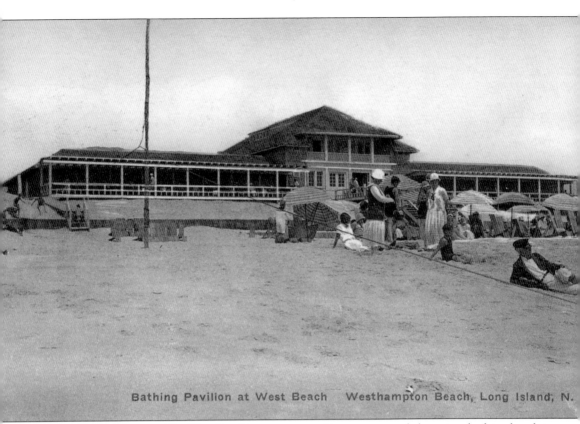

Bathing Pavilion at West Beach Westhampton Beach, Long Island, N.

WEST BAY PAVILION. The West Bay Company opened its extravagantly luxurious bathing beach in 1917 at the foot of Jessup Lane. Featuring a three-story pavilion, 200 lockers, a gift shop, tearoom, and swimming pool, West Bay was a modern resort, where women frequently, shockingly, bathed without stockings. In 1940, the Swordfish Club was built on the site of West Bay and retained the original pool.

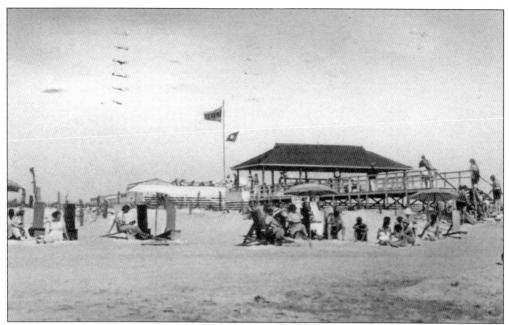

QUANTUCK BEACH CLUB, INC. In 1927, Quantuck Beach Club was founded by Quiogue families who merged the adjoining 100-foot-wide, ocean-to-bay lots they had bought in the 1880s to form an incorporated private club. It remains today much as it was then—a simple wooden structure with no pool or luxurious amenities. Contrary to West Bay's practices, Quantuck required men to wear bathing tops years after stores stopped selling them.

WILLIAM FLETCHER RAYNOR. Manager of the Westhampton Yacht Club in the 1920s and 1930s, "Fletch" was a bayman by trade who spent his life fishing and clamming. He and his wife, Louisa, raised eight children in a large house alongside Beaver Dam Creek. Neighbors remember the home as "one of the friendliest buildings on the planet, full of love and joy." The family would survive the coming tragedy.

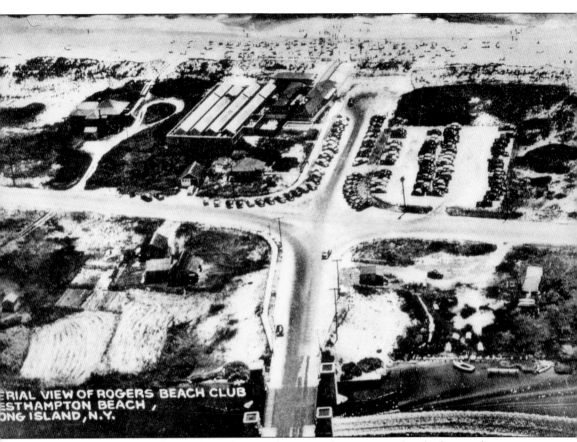

ERIAL VIEW OF ROGERS BEACH CLUB
ESTHAMPTON BEACH,
ONG ISLAND, N.Y.

IN THE PATH OF THE STORM. By mid-September 1938, the majority of sunbathers and vacationers had left the beaches and returned to their winter lives, unaware that a horrendous hurricane was forming. The storm would destroy their yacht clubs, their beach clubs, many of their boats, and hundreds of homes. Rogers Beach Club would never again look as it did in this aerial photograph taken around 1930.

Five

Hurricane and World War II
1938–1945

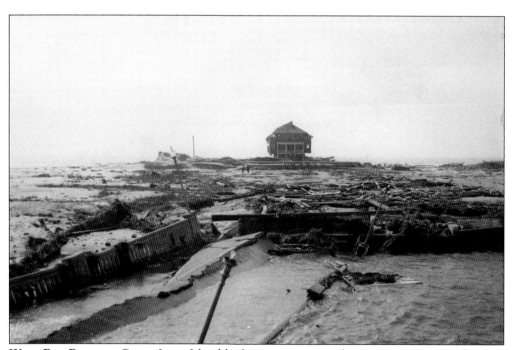

West Bay Pavilion Gone. Long Island had not seen a major hurricane since 1815 when, on Wednesday, September 21, 1938, a devastating hurricane hit Westhampton with virtually no warning. Carrying sustained winds of 121 miles per hour and peak gusts of 183 miles per hour, the storm came on a rising tide during the equinox.

DEATH AND DESTRUCTION. A beautiful September had caused vacationers to linger in their homes and hotels past the traditional end of the season. Those on Dune Road suffered the brunt of the storm, as the hurricane destroyed all but a very few of the 179 or so oceanfront properties, including the West Bay Corporation's luxurious resort and half of the West Bay Bridge. Some 29 people died in Westhampton.

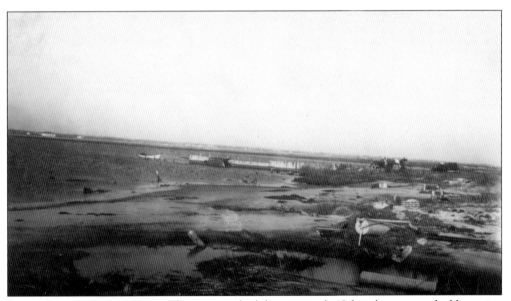

JARVIS HOUSE AT BUENA VISTA. The storm pushed the ocean tide 18 feet above normal, obliterating many structures. Reed Jarvis wrote about trying to find his family's house: "On September 23rd, we went by open launch to see the damage at Buena Vista. The only thing we could find of my grandfather's house was the driveway and a new sink that he had not had time to install."

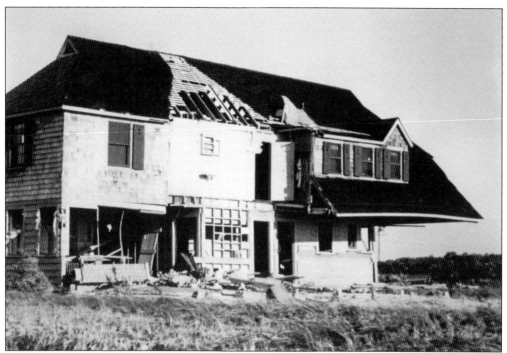

NORVIN GREENE HOUSE. The Greene family was entertaining a children's lunch party at their home on the western end of Dune Road when the ocean broke through the front door. As the waves pounded the house, the terrified group huddled in the attic, where they chopped an emergency exit in the roof. The Greene house was one of only a few on the barrier beach that survived the hurricane.

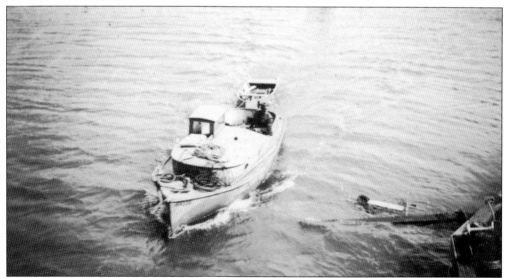

OTTO KAMMERER'S BOAT. Louise and Frank Driver were told that their 10-year-old daughter Pat, a guest at the Greenes' party, and all of the Dune Road occupants had perished. Frank later wrote that the next morning, as he and his wife waited at the telephone company for news, "Someone suddenly cried out, 'They've been found, and they're all right!'" Rescuers brought the children to safety in Otto Kammerer's boat.

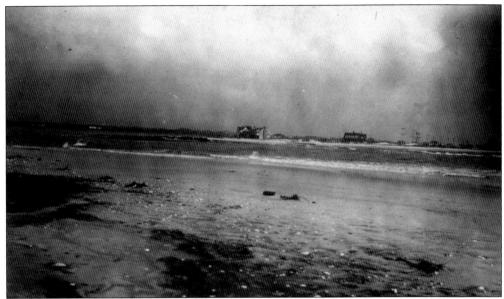

QUANTUCK INLET. Crashing over Dune Road, the ocean gouged numerous new inlets through the barrier beach, most of which were later filled. Shinnecock Inlet, however, was stabilized into a permanent opening, thus eliminating what had been a scenic and direct oceanfront drive from Westhampton to Southampton. Quantuck Beach Club had been situated in the center of the opening pictured here. This inlet was filled in and the club rebuilt.

ANDY AND MARJORIE JACOBS. Marjorie Jacobs, wife of Quantuck's manager Andy Jacobs, was making clam chowder in a cottage next to the club when the ocean broke through the dunes. She managed to wade through chest-high water to safety before the ocean tore an inlet 20 feet deep and 400 feet wide where the clubhouse had stood. The next day she and Andy returned to the cottage and ate the soup.

76

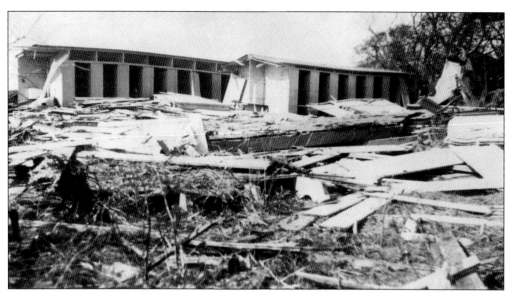

BATHHOUSES GONE MISSING. The remnants of the Quantuck Beach Club were found a mile north, across Quantuck Bay on the Quogue meadows off Assop's Lane. Large pieces of the bathhouses were intact, and several members went to the debris site and retrieved their bathing suits and other belongings. They reported that cans of talcum and face powder were still standing upright on the shelves in some of the lockers.

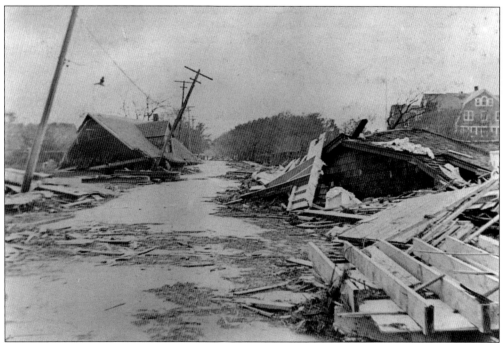

BEACH LANE WRECKAGE. The road on the mainland side of the Beach Lane bridge was littered with debris from Dune Road all the way to Main Street. Summer resident Barbara Hoey walked the beach the morning after the hurricane and remembered seeing more than a dozen car roofs sticking above the water. "We knew there had to be bodies in them . . . Airplanes circled overhead, looking for survivors."

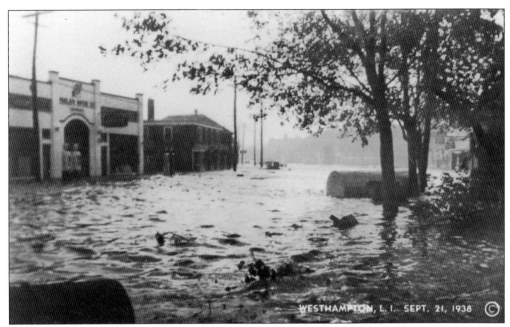

FLOODED MAIN STREET. As the hurricane approached, all the water left the bays, returning as an enormous wall that swept ashore. Main Street was under 8 feet of water at the street's lowest part, in front of what is now Magic's Pub. Raynor's Garage recorded a waterline 7 feet above floor level, and Cliff Raynor found fish swimming in his cellar and a striped bass in the back hall.

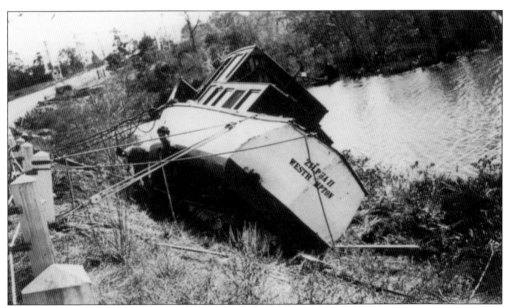

HIGHWAY OF BOATS. At Beaver Dam Cove, the storm surge—18 feet above normal—came rushing back into the bay, swept over the waterfront homes, and continued up Beaver Dam Creek. At the north end of the creek, the ocean waves rose over Montauk Highway, landing powerboats high up on the side of the road and sending a few sailboats to the far end of Cook's Pond.

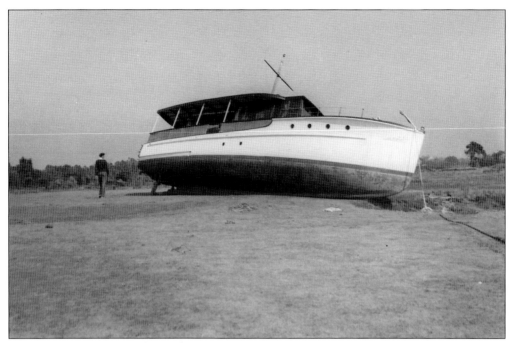

ON THE 12TH FAIRWAY. The Medinas' 46-foot yacht *Spindrift II* was carried from its mooring off Apaucuck Point to the Westhampton Country Club's 12th fairway half a mile away, where its buoy lodged in a sand trap. Nothing was left of the Medinas' home but a few bricks and water pipes. Ethel and Harold built a new house with I-beam girders on a double-strength, elevated foundation. It still stands today.

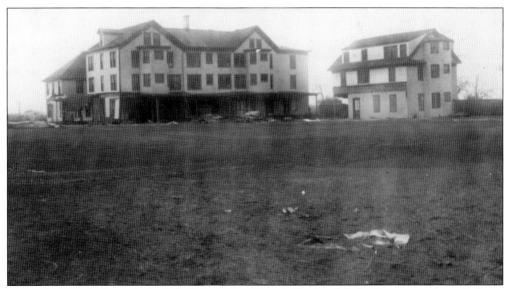

POINT HOUSE ASKEW. Apaucuck Point House owner Richard Culver was outside and alone, closing up the hotel, when the storm surge flooded the property, knocking the building askew on its foundation and sweeping him into a small cherry tree. When the roar of the hurricane finally ended and he was able to descend from the tree late that night, Richard's hair had turned white and he was nearly deaf.

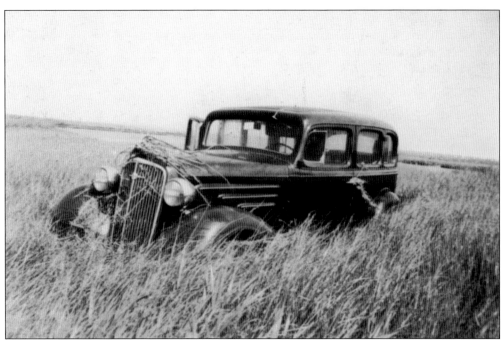

LOST POSSESSIONS. Cars, refrigerators, and oil tanks filled the bays. Furniture washed up on shorelines far from the homes of origin. Most families who lost their houses were able to retrieve almost nothing, but some were like Stanley Lewis and his family, who found their sideboard in a neighboring field, with the ancestral silver intact. The car pictured above was found in a meadow, far from the nearest road.

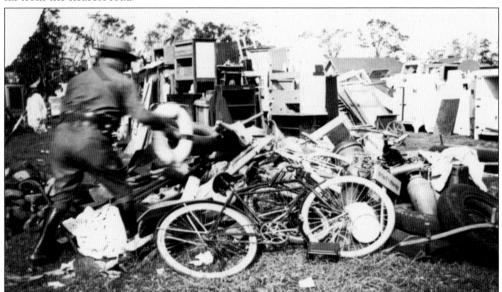

SALVAGE YARD. Crews gathered up furniture and personal possessions from the debris-laden roadways and beaches and brought it all to a collection point near the high school. There, as state troopers stood by to keep curious out-of-towners away, residents with village-issued permits browsed through rows of sorted furniture—pianos, ice boxes, bureaus—in an attempt to recover some of their belongings.

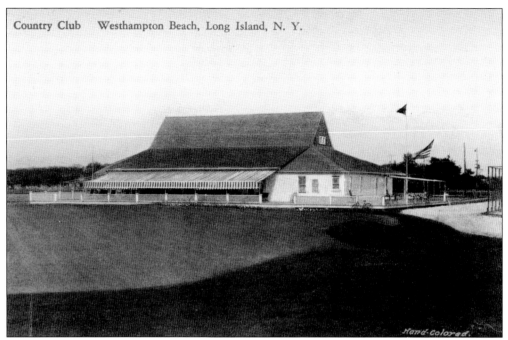

Country Club Westhampton Beach, Long Island, N. Y.

Hand-colored.

THE MORGUE. The wooden dance floor of the Westhampton Country Club served as a morgue for the 29 bodies that were recovered from the devastation. With the electric power down, friends and relatives had to search in half-darkness for loved ones. To aid the identification process, each body was propped up against the back of an overturned bar chair and illuminated by candlelight.

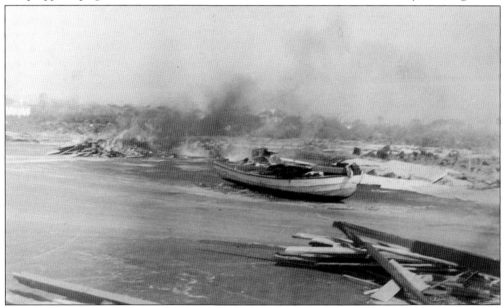

CLEANING UP. Boats were dragged out of hedges, Dune Road was rebuilt, and houses were reconstructed with lumber from the debris. Eventually much of the wreckage was burned in place, as in this photograph of Jessup Lane north of the bridge. The hurricane wiped out 40 percent of the assessed valuation of the village, but by June, the people of Westhampton were ready to welcome the summer visitors.

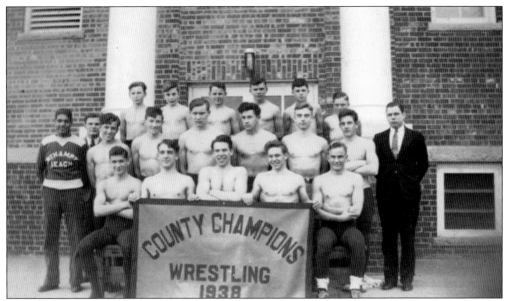

COUNTY CHAMPIONS. The Westhampton High School wrestling team were county champions in 1938. Smiling proudly into the camera, the young men were oblivious to the coming hurricane or to war clouds forming over Europe. The spring of 1938 was a time of peace, and life was good.

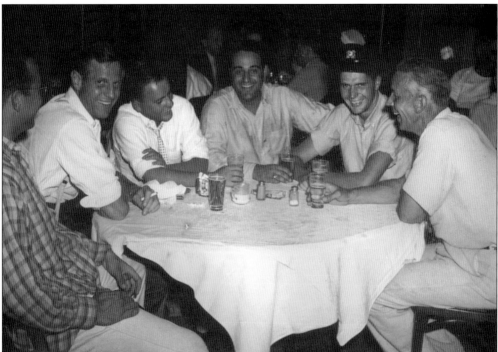

SAILORS' LAST HURRAH. Very shortly, these young men would experience a horror even worse than the hurricane. Martin Fink took this picture of his buddies—from left to right, Hank Freilinghaus, John Pflug, Edwin Holden, Arma Andon, Alec Nagle, and Harold Halsted—during the 1938 Race Week on Great South Bay. The United States entered World War II on December 8, 1941, sending most of these young men into combat.

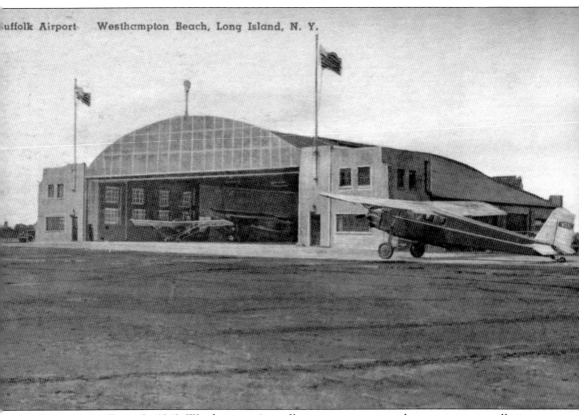

SUFFOLK AIR BASE. In 1942, Westhampton's small airport was activated as a training installation for American and Allied bombing crews, making the village home to thousands of servicemen-in-training. By 1964, at the height of the cold war, the air base had grown to be the world's largest air defense power complex, with 36 F-101 Voodoo supersonic jets and 60 BOMARC missiles to guard metropolitan New York.

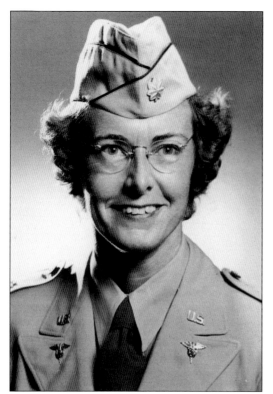

MAJ. CHRISTINE EHLERS. The daughter of Ludvig Ehlers, owner of Ehlers' Grocery Store on Baycrest Avenue and South Road, Christine (1908–2009) graduated from Arnold College of Hygiene and Physical Therapy in 1928 and served as a nurse in the Westhampton schools. She joined the Women's Medical Specialist Corps as a physical therapist at the outbreak of World War II and was stationed first in Georgia and later overseas in Europe and Hong Kong.

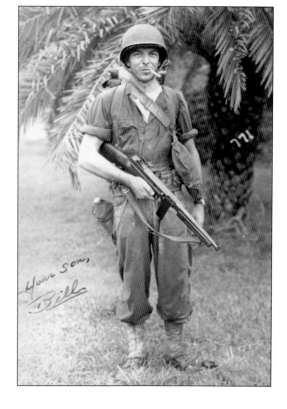

FLORIDA BIVOUAC. William T. Hulse Jr. began his World War II military training in Boca Raton, Florida, where this photograph was taken on July 24, 1943— six months after the battle of Guadalcanal. In a postcard headlined "On Bivouac," Bill wrote home to say, "Here is your son as he might look on Guadalcanal or Sicily (if they have palm trees there). A rough, tough, and nasty looking individual!!"

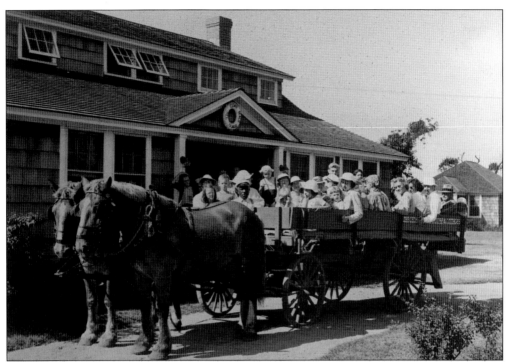

WARTIME BUGGY. In 1944, rationing limited the use of gas, meat, butter, sugar, and shoes. At the Cedar Beach Hotel, Wilton Morris drove the boardinghouse guests to the beach in a horse-drawn wagon, while others resorted to sailboats for gas-less transportation. Putting invention to work, Anne Keating managed to drive from Garden City to Remsenburg on 1 gallon of gas and a gallon of the cleaning fluid Renuzit.

SPOTTING ENEMY PLANES. Because of the danger of enemy bombers and the possibility that Long Island would be invaded, a 24-hour watch was established in the cupola atop the Westhampton Beach High School. Armed with cards identifying different planes and two telephone lines connected to national defense command centers, volunteers looked for enemy Junkers and Fokkers. The two-hour airplane-spotting shift was particularly popular as a date night activity.

NAZI SABOTEURS. Fearing an invasion by sea, Coast Guard foot soldiers with rifles patrolled the entire length of East End beachfront. Their fears were realized shortly after midnight on June 13, 1942. Four men, armed with explosives and intent on blowing up government arsenals, landed on a beach in Amagansett from a German submarine. They were arrested in New York City before doing any damage. A local resident subsequently found the Germans' raft hidden in the dune grass.

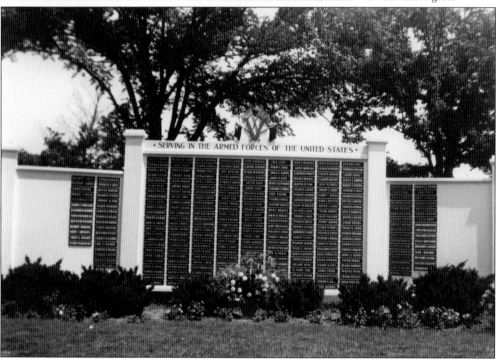

FINAL HONOR ROLL. A wooden triptych was erected on the Village Green listing those "Serving in the Armed Forces of the United States." By August 15, 1945, the names listed on the sign extended into three columns. Those killed in action were listed in gold and included Bruce Kavan, Ralph Fountain, Henry Andrewchu, Rodney Dayton, Joe Geer, Howard Finkman, Alex Cyrta, Stanley Dunn, Karl Lewin, and Russell Rose.

Six

RECOVERY AND REBUILDING
1945–1970s

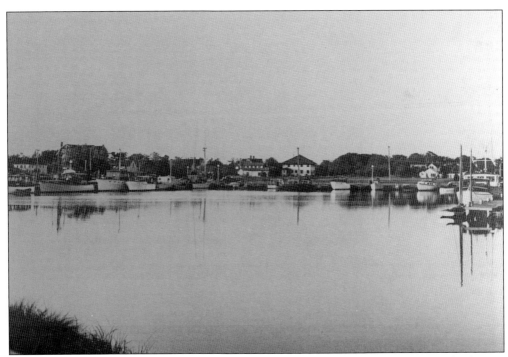

PEACE AT LAST. Most of Westhampton's soldiers returned home. The ocean was back where it belonged, and the bays were as quiet as the village marina in this 1940s photograph. The time had come for Westhampton to heal its people and to rebuild its economic base as a resort town.

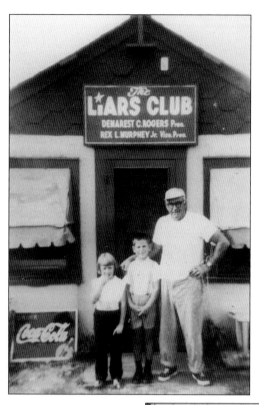

THE LIARS CLUB. Demarest Rogers sold Rogers Beach Club in 1949 and ran a bait shop named after fishermen who tell tall tales. He is pictured here in 1952 with two assistants for the day, Joy Dix (left) and Rex Murphy Jr. (center). Demi was such an ardent fisherman that when he and his fiancée, Ethel, went to the preacher to arrange their wedding, they told him they would be in on Saturday . . . if it was not codfish weather.

MAKING ICE CREAM. The lives of baymen like Fletcher Raynor (1875–1959) were not easy. An old bayman's adage was, "Do you know how to make a million dollars fishing? Start with two million." However, many Westhampton baymen of this era reportedly said that while they did not make much money, they had a lot of fun. And, good times or bad, there was always time for ice cream.

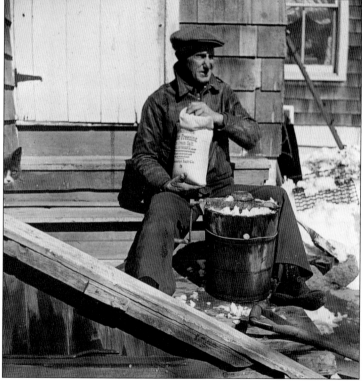

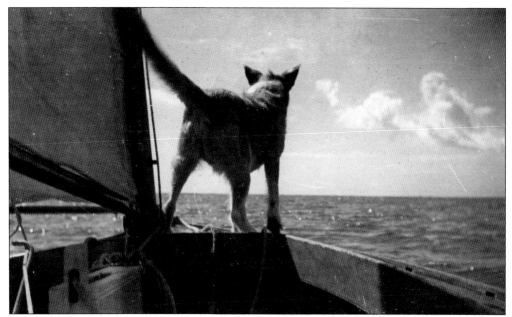

Looking For Seagulls. In the late 1930s and early 1940s, Fletcher's daughter Louise Raynor made her living digging clams in Moriches Bay. Each morning at dawn, she set out in her sailboat from Beaver Dam Creek—she to look for clams and her dog Count to search the horizon for seagulls. The bushel baskets in the cockpit were usually filled when the two companions returned in the late afternoon.

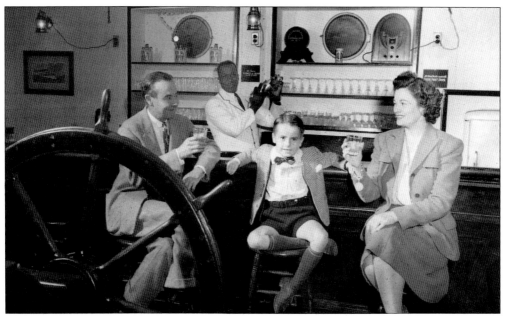

Sherman's Mint Juleps. This *c.* 1946 Christmas photograph sent out by Howell House owner George W. Carmany Jr. (1898–1971); his wife, Merle; and their son, George III extolled the bartending skills of Sherman Patterson (1895–1977), whose mint juleps were a local favorite. The master bartender went on to open his own restaurant called Sherman's, featuring soul food and his famous drinks, on Montauk Highway where Joe's is today.

THE PATIO, 1940s. Built in 1931, the Patio Hotel was for decades the meeting place for political intrigue, gossip, and fun. Dancing was a staple, both outside on the shady patio and inside on the dining room dance floor. Irene Magerry and her two girlfriends loved to dance so much they were always reluctant to leave, so the band hustled them out with a nightly rendition of "Good Night, Irene."

THE HOSE CART. The members of the Westhampton Beach Fire Department built a new hose cart in 1950 to replace its antiquated predecessor. The firemen posed proudly with their masterpiece behind the Glover's Lane firehouse.

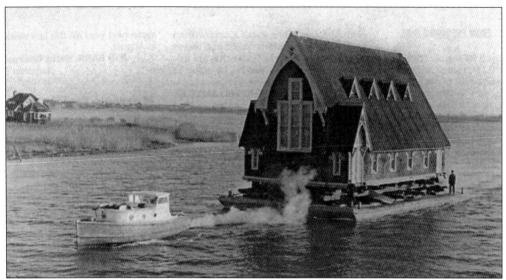

THE FLOATING CHAPEL. In 1950, the Union Free Chapel, a community house of worship built on Main Street and utilized by several different religions since its 1874 inception, was moved down Library Avenue, loaded onto a barge at the Yacht Basin by Davis Engineering, and floated down the bay to become a private residence on Dune Road, west of the Yardarm Hotel. It burned down in the 1970s.

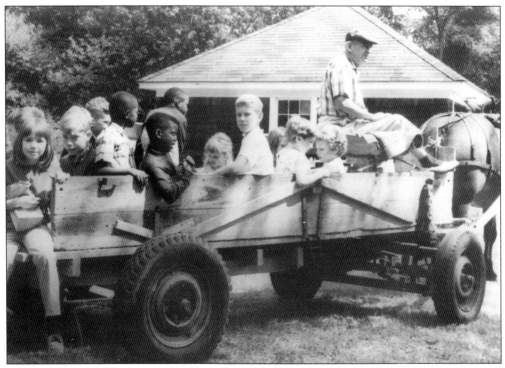

SUNDAY SCHOOL WAGON. A retired foreman of the Southampton Town Highway Department, Ralph L. Raynor (1889–1973) was a member of the Westhampton United Methodist Church. Here, in the late 1960s, he demonstrated how he made going to church a fun event for the Sunday school kids, with horse-drawn buggy rides.

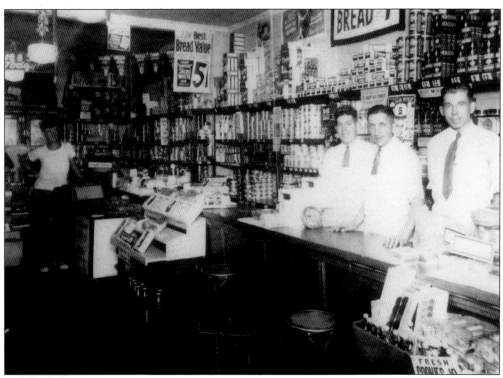

GELSTON WALTER, C. 1960. In the 30 years that he managed his grocery store, Gelston Walter (center, with Teddy Ocame, left, and Victor Dayton) witnessed the changing Main Street scene: C. L. Wines Practical Horseshoeing disappeared, the Tonsorial Salon became a barbershop, and celebrities like Cary Grant, who shopped at Weixelbaum's, and Arthur Treacher, who chinned daily with Gloria Seeley over the newspaper counter, came to town.

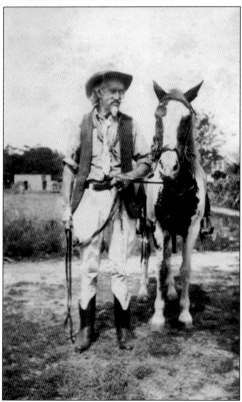

"WILD BILL" EAGER. Replaced as mounted constable by policemen in automobiles, Winfield made a living farming, selling fish and eggs, and giving riding lessons. He met his wife, Mary, at Lomas' Dance Hall, where they won the cakewalk contest. Together they had 12 children. An accomplished artist and a born showman, Winn livened up the village, occasionally falling off his horse amidst the Main Street traffic after too much tippling.

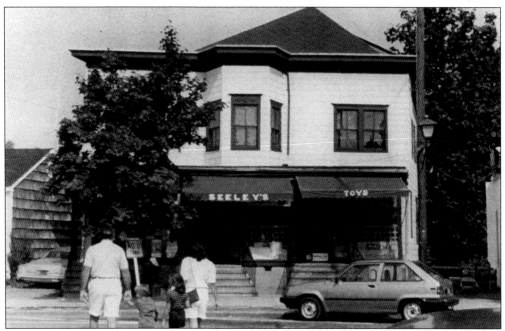

GLORIA'S. By the 1930s, James Seeley's store was known far and wide simply as "Gloria's" after his youngest daughter, who took over the business. Gloria worked 12–14 hours a day, seven days a week. Always on the lookout for juvenile shoplifters, she was impatient with browsers, miserly with conversation and smiles, but in her love for the village, openly enthusiastic about every holiday, parade, and civic celebration.

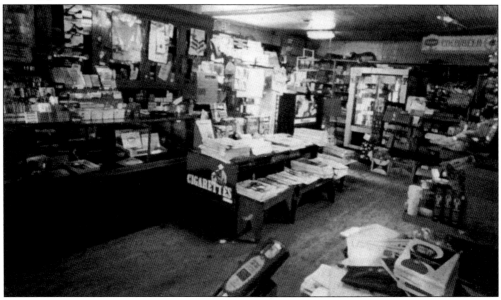

INSIDE GLORIA'S STORE. The floors were scratched and old, and the dust-laden shelves were filled with ancient toys and a wondrous collection that left children awestruck. A yappy Pekinese ruled the store, and a cat or two paperweighted the newspaper pile, over which Gloria hung a sign that read: "The Surgeon General has determined that taking the top paper is NOT dangerous to your health."

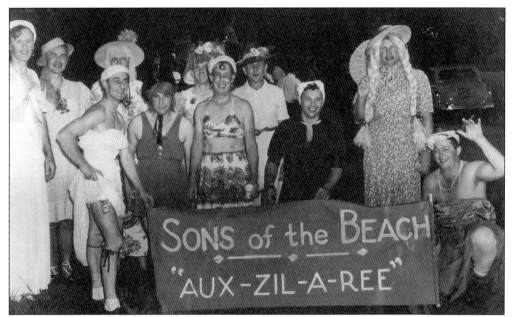

FIREMEN'S OUTING, 1940s. The Sons of the Beach acquired help in the form of the Ladies' Auxiliary, who supplied hot drinks and food at the scene of midnight fires and raised money for firefighting equipment. The firemen were not above making good-humored fun of the auxiliary, as they did at this fire department outing. In the 1990s, the Sons of the Beach began accepting women as firefighters.

REBUILDING THE DUNES. The oceanfront dunes were once very high and partially covered with salt hay and cranberry bushes, as they were in this photograph from the early 1900s. The 1938 hurricane flattened some of the dunes, but over the years nature and federal restoration projects have rebuilt the barrier beach, to the extent that it is today heavily populated with both private residences and condominiums.

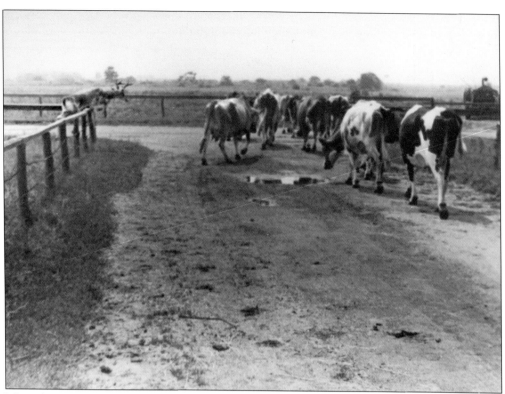

MAIN STREET COWS. During World War II, an antiaircraft gun was situated in Ed Stevens's cow field at the corner of Main Street and Potunk Lane. It was gone by 1950, when this photograph was taken of a young stag (left) that frequently joined the cows at dinnertime. For generations, the Stevens family operated a dairy farm between Main Street and Stevens Lane and between Mitchell and Potunk.

DOCTOR MERLE. James Merle (1914–2002) responded whenever he was called, often arriving at his patient's bedside late at night with his pajamas peeping out from below the cuffs of his pants. Stooped as a result of a World War II accident that sent the ambulance he was in over a cliff, he never learned to drive. Instead, he hitchhiked everywhere. He was photographed in 1989 at age 75 thumbing a ride to Central Suffolk Hospital for his daily rounds.

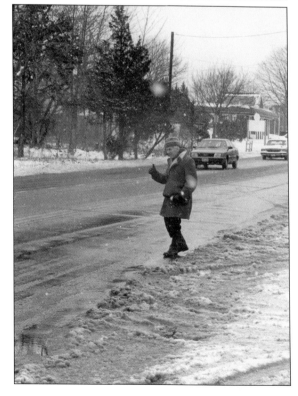

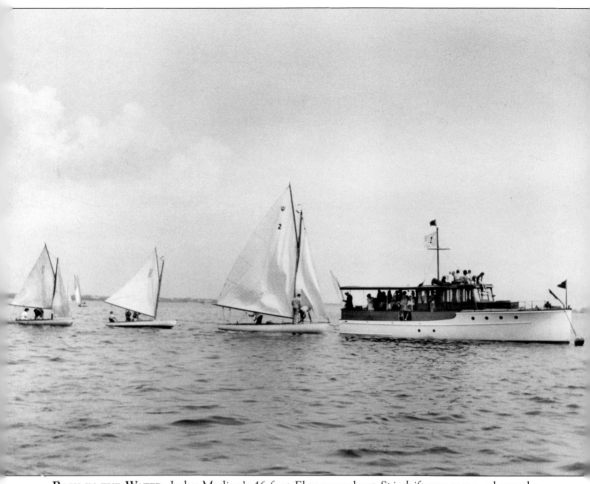

BACK IN THE WATER. Judge Medina's 46-foot Elco powerboat *Spindrift* was removed somehow from the Westhampton Country Club's golf course—one boatbuilder speculates that possibly the yacht was righted with a crane and lifted onto a custom-made cradle that was then rolled atop tree trunks several hundred yards to the bay. By 1954, the *Spindrift* was back in Moriches, taking a turn serving as committee boat for the Saturday races.

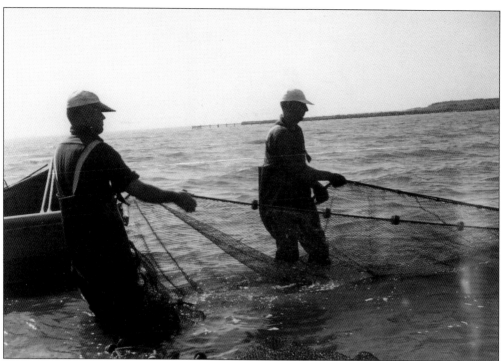

HAULING IN FISH. In the early 1950s, Marvin Raynor (left) and his brother Sidney were still fishing the bays for perch with their gill nets and haul-seining for bigger catch in the ocean. By the 1970s, however, Westhampton had become almost entirely a service community, with comparatively little industry or farming and very little commercial bay fishing.

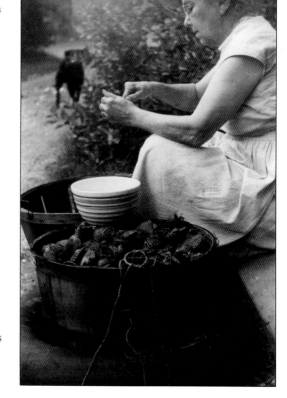

SHUCKING SCALLOPS. Louisa Raynor is pictured shucking scallops in the 1940s. The wife of bayman Fletcher Raynor, she also helped to make and mend the webbing for the fishnets. Louisa's habit was to sit by the radio while she knitted the pieces of linen together for the various nets. Baymen, seine nets, and eel pots are few and far between these days, but scallops are still an autumn treasure.

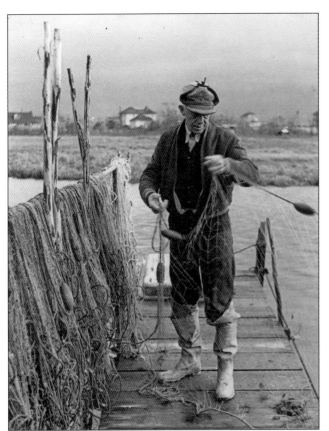

SIDNEY BENJAMIN. Louisa Raynor's brother Sid was a full-time bayman, who fished with nets, dug soft and hard clams, and dredged for eels. He was also an expert sailor, a so-called "professional" because he was hired to navigate and crew for William Atwater's sailboats and for his 65-foot twin-screw powerboat *Wilanida*. Berthed in a large boathouse in Goodman's Creek, the *Wilanida* was destroyed in the 1938 hurricane.

CLAM BOAT WITH GUESTS, 1940s. The sun was just coming up on a beautiful morning, but Fletcher Raynor and his brother-in-law Sid Benjamin (right) were already in Fletcher's clam boat, dredging eels in Beaver Dam Creek. On this particular day, they had three guests on the cabin top: Drayton Schwarting, an unidentified young woman, and the dog, Count.

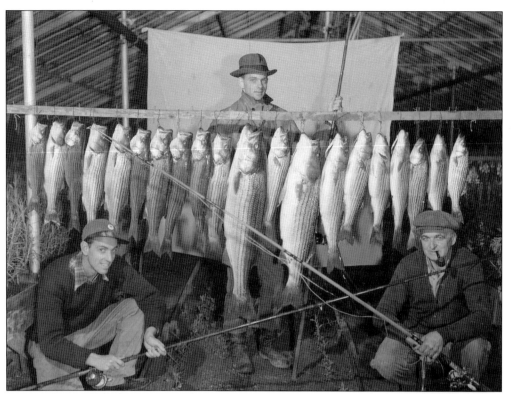

STRIPED BASS. With the opening of Moriches and Shinnecock Inlets, the influx of ocean water increased the salinity content of the brackish bays, resulting in a growing number of striped bass. Rob Staniford stood proudly behind a handsome string of striped bass, as Marshall Switzer (left) and Harold Beecher Halsey knelt in front.

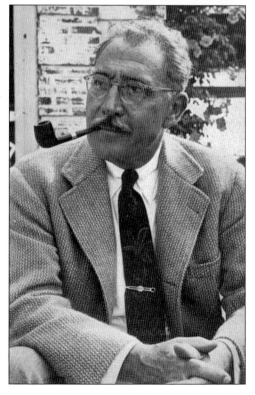

JUDGE MEDINA, 1951. Every Fourth of July for 20 years, Ethel and Harold Medina invited area residents to their bayfront estate to view Grucci fireworks. Villagers came by water and land, covering Beaver Dam Cove with boats and the Medinas' lawn with picnickers. A celebrated federal judge pictured on the covers of *Time* and *Newsweek* magazines, Judge Medina sat on the U.S. Court of Appeals, retiring in 1988 at the age of 90.

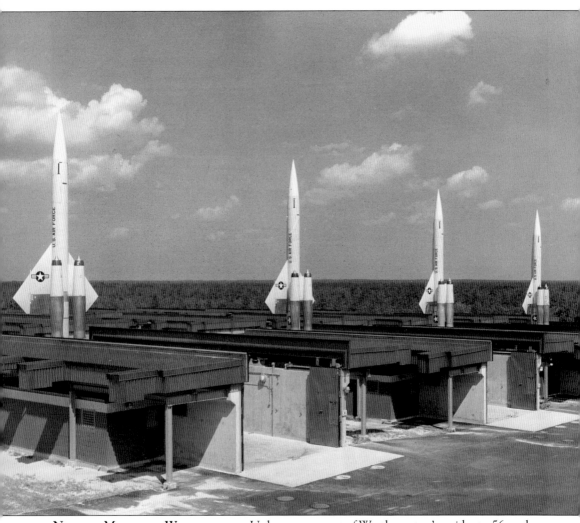

NUCLEAR MISSILES IN WESTHAMPTON. Unknown to most of Westhampton's residents, 56 nuclear-tipped missiles lay hidden in the woods off Old Country Road from 1959 to 1964. Housed in garage-sized bunkers whose roofs opened like clam shells, the BOMARC missiles guarded the East Coast against a Soviet nuclear attack during the cold war. America's nuclear defense system was subsequently moved to other undisclosed locations. (Courtesy National Museum of the United States Air Force.)

Seven

BONDING THE OLD WITH THE NEW
1970s TO PRESENT

END OF THE BOARDINGHOUSE ERA. Mortimer Howell's Restacre was moved north up Beach Road in the late 1930s to make room for the new post office. The grand old hotels like Howell House, Apaucuck Point House, and the Hampton Inn are gone, some burned in fires, others replaced by single-family homes. The summer population is now housed in private residences, bed and breakfasts, and small inns.

TAXPAYERS' REBELLION. Some homes—multigenerational farmhouses as well as summertime mansions—were taken down because the owners were either unable to pay the ever-increasing property taxes or because the owners thought maintaining the structure was not worth the amount the government demanded in taxes. Henry O'Brien had the fire department burn down his historic 32-room Seafield Lane "cottage" known in 1965 rather than pay the taxes and maintenance due on the house.

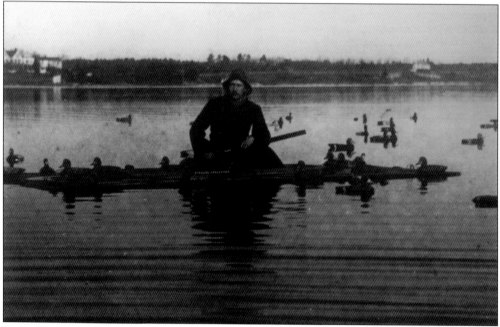

DUCK HUNTING. Quiogue attorney Bill O'Brien sat in his punt, surrounded by decoys, in this photograph from the early 1960s. Duck hunting was one of Westhampton's earliest advertised attractions. Grass-covered hunting blinds can still be seen on the wetlands and marshes, but the proliferation of residential construction, new licensing requirements, and the diminishing number of waterfowl have contributed to the decline of hunting opportunities.

PARARESCUERS. Westhampton's Gabreski Airport is today home to the 106th Rescue Wing of the New York Air National Guard, the most highly trained rescue unit in the armed forces. The 106th's pararescuers fly Pavehawk helicopters and C-130 transports. Trained in combat ocean diving, underwater rescue, parachute jumping, and special combat medical operations, they are the best of the best. When not in combat or needed elsewhere, they watch over Westhampton.

WESTHAMPTON WILDFIRES. In August 1995, a wildfire raged for five days in and around Westhampton Beach, burning 6,000 acres of protected pine barrens. More than 5,000 volunteer firefighters and 225 fire companies responded, coming from as far away as New Jersey, New York City, and West Point. The flames charred the railroad depot, missed the Air National Guard's underground fuel tanks by only yards, brushed by a firewall built around a propane gas center, and surrounded a 150-home residential development. While helicopters dropped water from huge airborne buckets that they continuously refilled in nearby Beaver Dam Cove, the volunteer firefighters fought the blaze with determination and ingenuity.

SAVING THE HOMES. As the fire approached a large housing development near Gabreski Airport, the firemen managed to divide the fire so that it swept by on either side of the 150 homes without damaging them. The fire was finally extinguished, with no loss of life and minimal property damage. In gratitude, the village held a Heroes' Parade a few weeks later, in which hundreds of firemen and firefighting vehicles passed in review before a cheering crowd of onlookers. The first scrub oak sprouts were visible 10 days after the fire, pushing their way up through the ashes.

CASA BASSO. Valerio "Rene" Mondini (at right in 1997) was interned in an American prison during World War II because he was Italian. But in 1955, he bought Mama Basso's restaurant and for the next 30 years served delicious Italian food to his American friends. Bejto Bracovic (left), an Albanian refugee from Yugoslavia, and his wife, Zyli, run Casa Basso today, surrounded by Theophilus Brouwer's towering swordsmen and imaginative sculpture.

RIA DEL BENE. Ria (1919–2006) was still seeing customers in 2001, sixty-three years after her beauty shop opened. She never had children but claimed all the Westhampton school kids as her own, attending every school concert as well as every village meeting. She also started the Senior Citizens Club and was a village trustee. In 2007, the village dedicated the Ria Del Bene Memorial Playground in her memory.

WARREN "RED" ECKART.
Shirley and Red Eckart ran
Eckart's Luncheonette from
1949 until 1991, when they
passed the management of
the store to their daughter
Dee McClain. For 31 years,
Red worked two jobs, at
the store from 7:00 a.m. to
2:00 p.m. and as clerk at the
village's Justice Court from
2:00 p.m. to 6:00 p.m. He
passed away in 2004. The
restaurant will celebrate
its centennial in 2011.

GENERATIONS OF BOATBUILDERS. The three most recent generations of the famous Scopinich boatbuilding family are Fred Scopinich Jr. (right), his son Fred A. Scopinich (center), and grandson Kevin Scopinich (left), pictured in this 2009 photograph repairing a 1945 Carter sailboat at the family's Hampton Shipyard. The Scopinichs gained fame building boats for both the Coast Guard and the rumrunners during Prohibition. (The rumrunners' boats were always faster.)

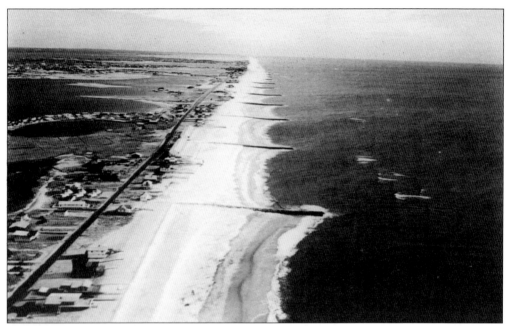

THE JETTIES. Hoping to limit the erosion of the dunes on Westhampton's barrier beach, the federal government joined New York State and Suffolk County in a plan to build 22 stone "groins" from Shinnecock Inlet to Moriches Inlet. By 1970, after 15 of the 450-foot jetties had been completed, construction ceased as the result of a dispute over the uneven sand disbursement in the now-interrupted littoral flow.

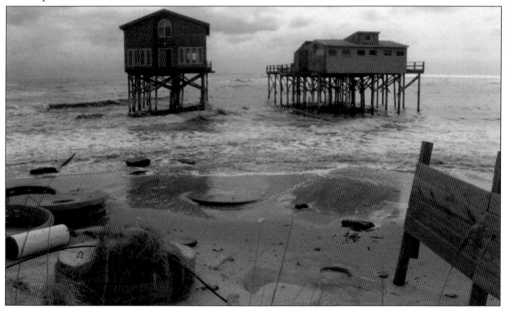

BARRIER BEACH DISASTER. Without the last seven jetties of the 22-jetty project, 2 miles of Dune Road, from the end of jetty 15 to Moriches Inlet, were left exposed to the ocean sweep as shown in this 1993 photograph. As a result, the 700 and 800 residential blocks disintegrated and an inlet 3,200 feet wide and 20 feet deep opened where 120 houses had once stood. (Copyright First Coastal Corporation, 2009.)

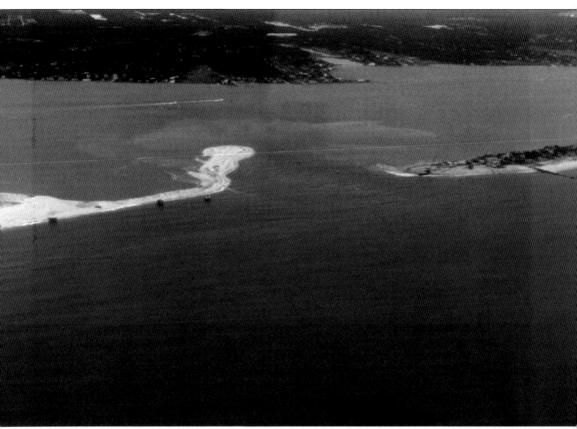

ONE MILE INLET. In 1993, with their houses gone and their property swept away by the ocean, the homeowners of Dune Road's 700 and 800 blocks formed the incorporated village of West Hampton Dunes. As such, they successfully sued to have the inlet (pictured here in 1995) closed, the jetties modified, and the barrier beach rebuilt. Today the Dunes is a densely built residential community. (Copyright First Coastal Corporation, 2009.)

PERFORMING ARTS CENTER. On July 4, 1998, the beautifully restored 1934 movie theater on Main Street reopened as the Westhampton Beach Performing Arts Center, saved by a consortium of community groups who were intent on having a cultural/entertainment center in the village. In its first year, the 425-seat center offered showings of classic films and concerts by such notables as Marvin Hamlisch, Itzhak Perlman, Lionel Hampton, and Billy Joel.

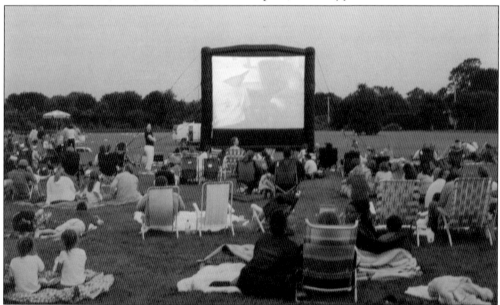

THE GREAT LAWN. Together with the Village Green, the Great Lawn (at the opposite end of Main Street from the Village Green) is the site for a wide variety of community activities, including seasonal art and crafts shows, Easter egg hunts, the Rotary Club flea market, holiday celebrations, and the Thursday Concerts series. The Tuesdays for Children program occasionally includes big screen movies, such as the one pictured here on the Great Lawn.

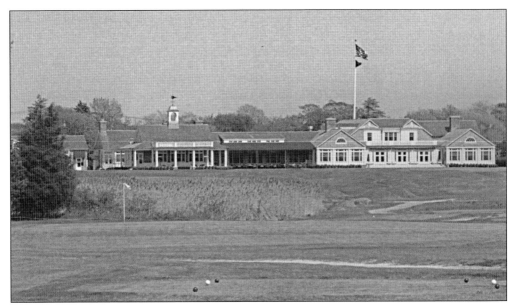

WESTHAMPTON COUNTRY CLUB, 2009. In 2005, the 1898 clubhouse was torn down and rebuilt with modern amenities, including air conditioning. The 19th-century baseball field, trapshooting range, and boat dock are long gone. The private club today still features the 18-hole golf course with a seaside-links look designed by Seth Raynor in 1914, plus tennis courts, a junior sports program, and a variety of social activities, including bridge and mahjong.

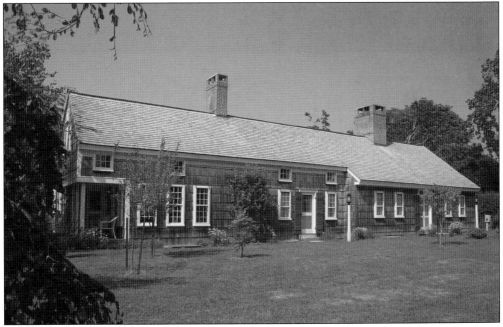

HEZEKIAH HOWELL HOMESTEAD. Built in 1727, the homestead of early settler Hezekiah Howell, one of the first two white people to buy land in Catchaponack, still stands on Westhampton Beach's Main Street. Howell descendants occupied the house continuously for more than 200 years, until 1942. Today Larry Jones, a specialist in historical restorations, owns the house and has returned it to 18th-century authenticity.

ELIZABETH DUERSCHMIDT, ARTIST. For the past 25 years, Liz Duerschmidt has been capturing nostalgic scenes from Westhampton's past. The Tuthill Museum featured her multi-medium work in a 2009 exhibit entitled Historic Sites from the Artist's Perspective. A postal employee for the past 30 years, Liz and her mailbag are a familiar sight on Main Street.

CHARLIE HALSEY, BROOM MAKER, 1992. Colonial farm tools and household items hold an honored place in Long Island's history. Westhampton resident Charles Halsey (1911–1993), a descendant of one of Southampton's earliest pre-Colonial families, was a duck farmer and a builder before he became Judge Medina's estate manager. One of his favorite hobbies was making Colonial brooms, which he exhibited at historical societies, school fairs, and community gatherings around the East End.

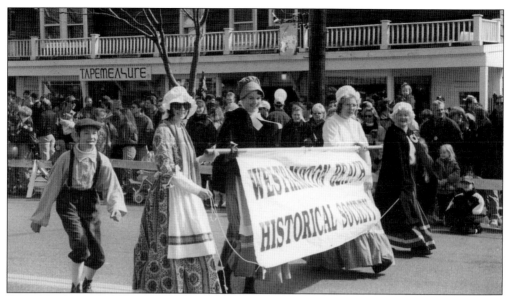

An Historical Society is Born. The idea of founding an historical society was born in the kitchen of the Hezekiah Howell homestead. It was the brainchild of Ridgie Barnett, Anne Kirsch, Patricia Andrews, Beecher Halsey, Greg Minasian, Joan Derryberry, Blair Rogers, Mary Fritchie, Rev. Wilbur Sadleir, Frank Gould, Alfred Loreto, Marion Van Tassel, Ria Del Bene, and Barbara Betts. The Westhampton Beach Historical Society proudly introduced itself in the 1995 St. Patrick's Day Parade.

Founders at Work, c. 1993. In 1991, the historic 1841 Josiah Tuthill farmhouse was donated to the society and relocated to its present site on Mill Road. After four years of fund-raising by history-loving volunteers, the society's Tuthill House Museum opened its doors to the public. Volunteers Barbara Gill Betts (left), Marion Raynor Van Tassel (center), and Ridgie Barnett are shown here scraping one of the fireplaces.

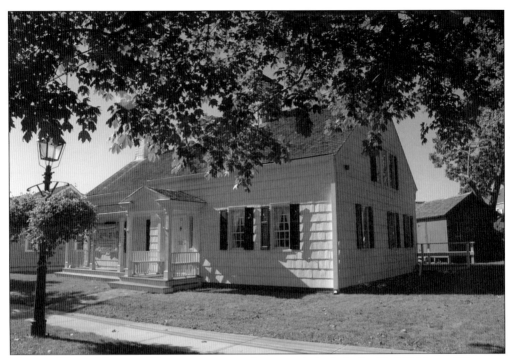

TUTHILL HOUSE MUSEUM. The museum grounds currently include the Tuthill House, Thurston Raynor's milk house, an historic carriage house, and the yet-to-be-restored Foster-Meeker House (far left). The society's mission includes promoting historical research, gathering local history, and participating in community events to promote the love and appreciation of local heritage. In the photograph above, a placard in front of the museum advertises the 2009 Liz Duerschmidt exhibition.

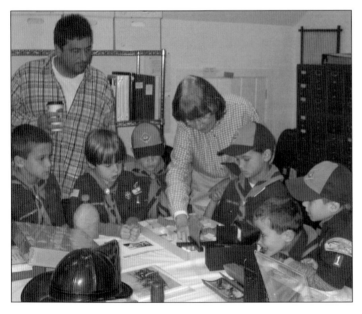

TEACHING THE NEW GENERATION. The historical society takes every opportunity to teach residents about the past. In 2009, curator Virginia Kendall gave a special tour of the artifacts room to Cub Scouts Grayson Fox, Blake Busking, Matthew Leotta, Cole Federico, Jeffrey McBurnie, Kevin Lanning, James Immordino, and den father David Fox. The society also offers walking tours, lectures, and potluck dinners to inspire shared memories on particular topics.

Eight

Footprints in the Sand
Building the Character
of Westhampton

SALT SPRAY ROSES. Westhampton is still as beautiful today as it was in this 1970s photograph by George Haddad, but population growth continues to threaten its fragile infrastructure. Various conservation groups—federal, state, and local—now serve as watchdogs to try to protect the land the Algonquin Nation cherished.

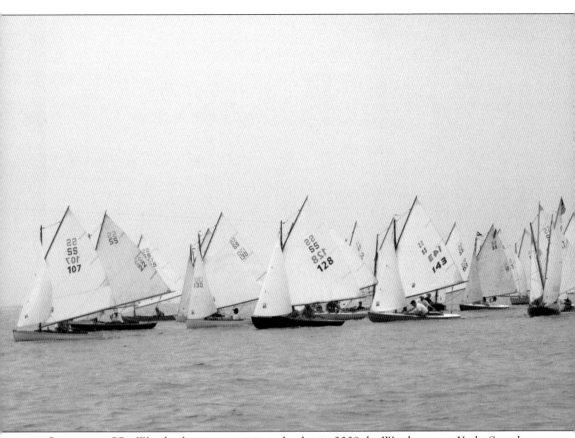

SAVING THE SSS. Wooden boats are a rarity today, but in 2008 the Westhampton Yacht Squadron celebrated the 100th anniversary of the 16.5-foot, gaff-rigged wooden sailboat known as the SS. Only 156 were ever built, and in 2005, the centennial organizers believed that only 10 or so were still in existence. Three years later, as television cameras recorded the event, 38 SSs sailed in parade formation on Moriches Bay in front of hundreds of admirers.

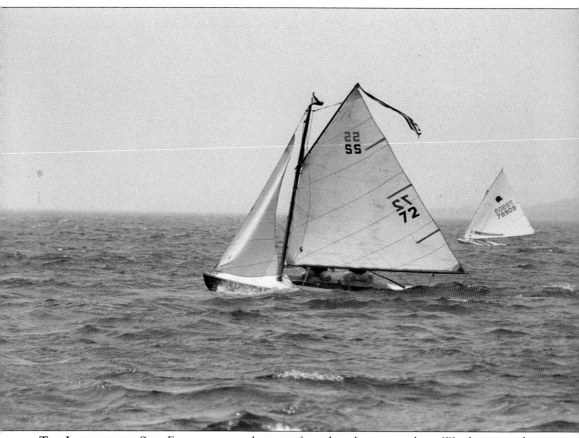

THE LOVE OF THE SEA. Easy access to the waterfront has drawn people to Westhampton for hundreds of years, although powerboats far outnumber sailboats now. But when the wind blows and the sun glistens off the waves, a sailboat speeding across the bay, like the SS being raced here by Ted Conklin III and Arma Andon Jr. in this 2004 *Southampton Press* photograph, is a beautiful sight.

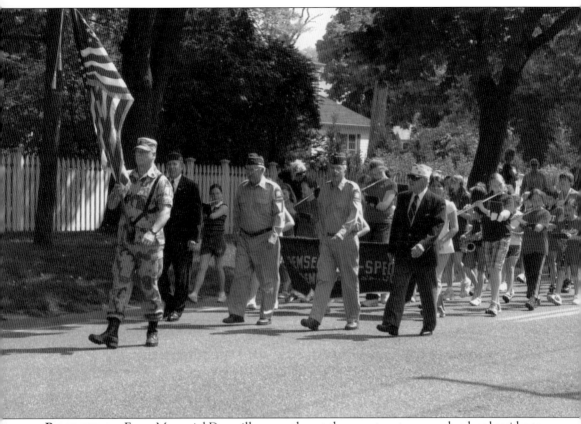

REMEMBERING. Every Memorial Day, villagers gather at the cemetery to remember local residents and others who have fought for America. Each year, the Remsenburg-Speonk Elementary School's entire student body—pictured here in 2007 with the school band and a few honored veterans of foreign wars in the lead—march nearly 2 miles from the school down rural, almost-deserted South Country Road to a stone monument for a ceremony of remembrance.

FIREMEN ON PARADE. On festive occasions such as the village's annual St. Patrick's Day Parade, the Westhampton Beach Fire Department shines up its equipment, the firemen don their formal uniforms, and a contingent marches down Main Street amid the floats, the scout groups, and the bands. Former fire chief Dick Van Tassel is pictured waving from the passenger seat of an historic showpiece Mack B95 Thermodyne pumper. The department has over 100 volunteer firefighters, 15 pieces of apparatus, and a state-of-the-art water boat.

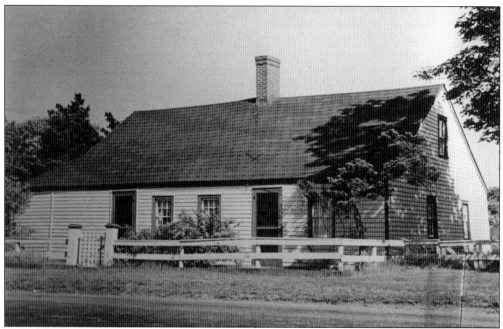

FOSTER-MEEKER HOUSE, THEN. Possibly the oldest house still in existence in Westhampton Beach, the Foster-Meeker home was located on the south side of East Main Street, near Turkey Bridge. It was once a designated drop-off for mail, which was left there by the stagecoach as it came down Griffing Avenue from Old Country Road. In 2008, the building was moved onto the grounds of the Westhampton Historical Society.

FOSTER-MEEKER HOUSE, NOW. The 1735 Foster-Meeker House now sits alongside the Tuthill House Museum, facing Mill Road. While the building is not currently usable, the historical society hopes to restore the house to its original look and configuration. If the fund-raising is successful, the house will become an educational center, suitable for lectures and historical programs.

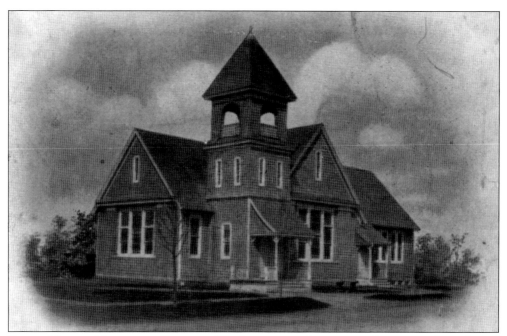

BEACH UNITED METHODIST CHURCH. Westhampton is fortunate to have a good number of buildings, residential as well as commercial and religious, that have survived for more than 100 years. The number becomes fewer each year, due to obsolescence, decay, and economic factors. Many of the buildings, such as the historic 1892 Beach United Methodist Church, have had to resort to community appeals in search of restoration funds.

FIVE GENERATIONS, 1964. Westhampton is still home to almost all of the families who settled Catchaponack. They are a tough breed. Grace Tuttle Halsey (with from left to right Genevieve Halsey Raynor, Marion Raynor Van Tassel, Dick Van Tassel, and newborn Rick Van Tassel at Rick's christening) weighed less than 2 pounds at birth and was kept alive in the warming oven of a wood stove. She lived to be 102.

RAYNOR ROUNDUP, 1994. The salt spray roses, sandy beaches, creeks, and bays make up the physical charm of Westhampton, but the people who have lived here formed its enduring character. Among the families who settled Catchaponack are the Raynors, who gather periodically in "Raynor Roundups" to relive and preserve a heritage that goes back to 1634. They have their own Web site in order to connect with family members globally and a newsletter to update members on Raynor family members and happenings. So numerous are they that they have to search a 4-inch-thick genealogy to find how they are related to one another.

THE LEGENDARY GLORIA. When Gloria Seeley died in 1984, many villagers felt the had lost a member of the family because she had always been there, behind the counter, as reliable as the morning sunrise. Liz Duerschmidt's poster of the store was so popular that it is now a collector's item. Local historian Pat Shuttleworth photographed the famously solemn Gloria smiling across the counter at Pat's father, Frank Driver, in 1982.

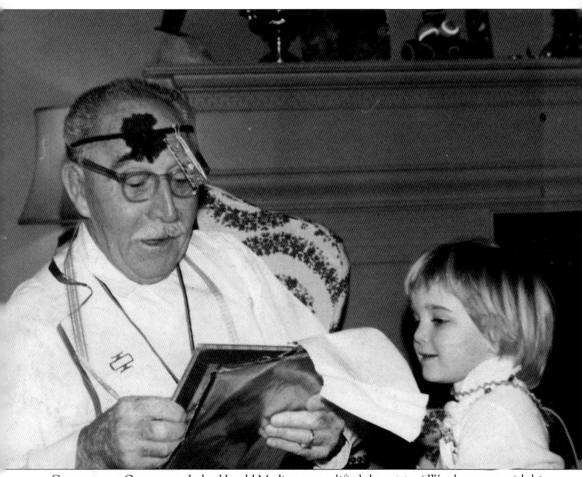

CELEBRATING OURSELVES. Judge Harold Medina exemplified the spirit of Westhampton with his annual Fourth of July fireworks show. What could be more important or more fun than celebrating ourselves, he said. Whether he was swallowing a tent caterpillar to enlist schoolchildren in his caterpillar-eradication program, setting off cherry bombs on the Fourth of July, or buying books for the Free Library, he thought every day spent in Westhampton was a gift. He is pictured here on Christmas Day 1972 with great-granddaughter Amanda Murray. The judge passed away in 1990 at the age of 102.

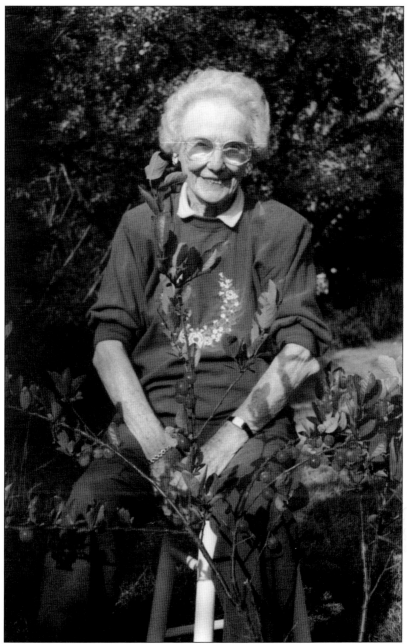

SALLY'S BEACH PLUM HOOTCH, 2000. Sarah Raynor Lind (1911–2002) epitomized the hardworking spirit of eastern Long Islanders. She worked the family's South Road farm with her mother after her father's early death, finished college, and taught second grade in the Westhampton Elementary School for 31 years. "Sally" was famous for her beach plum "hootch," and long after she was too old to drink it herself ("Oh, what a kick it has!" she said), her neighbors begged her to continue making it for their sake. Sally's recipe: Fill a quart jar with beach plums around September 1, when they are deep purple (and before the birds get them); add a quarter-pound of rock candy; then fill the jar with vodka and set it aside until Thanksgiving Day. As Sally used to say, "Once you drink the hootch, you won't remember if you ate the turkey."

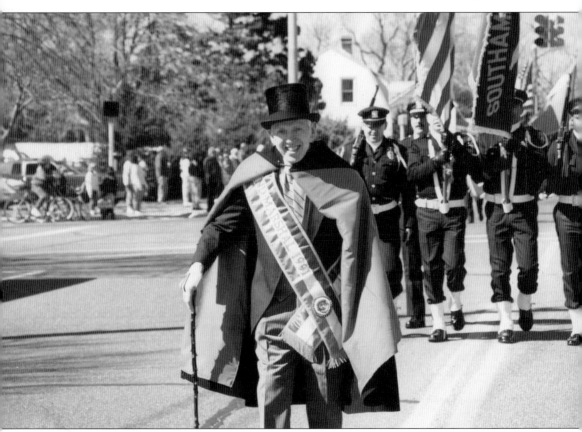

Doc Merle, Grand Marshall. Dr. James Merle (1914–2002) was a village treasure, and he will long be remembered as the compassionate doctor anyone could call at any time of the day or night. "You have to remember that each of these patients are people," he once said. "And they matter. And they have to matter to themselves to get well." Named the Westhampton Rotary Club's Man of the Years in 1982 for his service to the community (so named because it was the only time the club ever honored anyone with the award), Doc Merle was grand marshal of the village's St. Patrick's Day Parade in 1991.

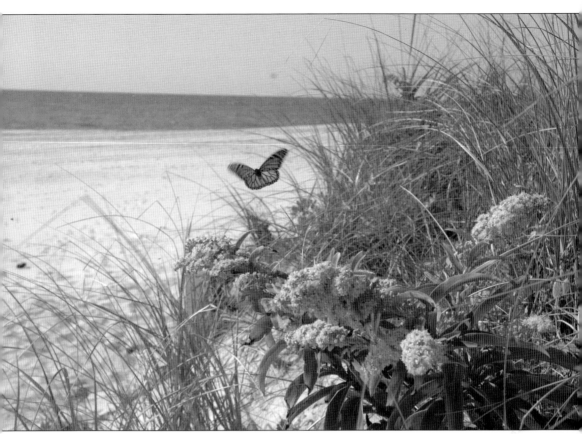

THE BEACH TODAY. The sea defines Westhampton. The wide stretch of white sand that runs along its southern border is the place where its people have been coming for hundreds of years to play, work, socialize, and be alone. The power and beauty of the ocean waves are life-sustaining forces, as is the sense of peaceful solitude that comes with being in such a primeval place, with the seagulls, the sea breezes, and September's monarch butterflies.

www.arcadiapublishing.com

Discover books about the town where you grew up, the cities where your friends and families live, the town where your parents met, or even that retirement spot you've been dreaming about. Our Web site provides history lovers with exclusive deals, advanced notification about new titles, e-mail alerts of author events, and much more.

MADE IN THE USA

Arcadia Publishing, the leading local history publisher in the United States, is committed to making history accessible and meaningful through publishing books that celebrate and preserve the heritage of America's people and places. Consistent with our mission to preserve history on a local level, this book was printed in South Carolina on American-made paper and manufactured entirely in the United States.

This book carries the accredited Forest Stewardship Council (FSC) label and is printed on 100 percent FSC-certified paper. Products carrying the FSC label are independently certified to assure consumers that they come from forests that are managed to meet the social, economic, and ecological needs of present and future generations.

FSC
Mixed Sources
Product group from well-managed
forests and other controlled sources

Cert no. SW-COC-001530
www.fsc.org
© 1996 Forest Stewardship Council

Find Your Place in History.